IMAGES
of America

The UNIVERSITY *of* GEORGIA
REDCOAT BAND
1905–2005

IMAGES
of America

The UNIVERSITY *of* GEORGIA
REDCOAT BAND
1905–2005

Robin J. Richards

ARCADIA
PUBLISHING

Published by Arcadia Publishing
Charleston SC, Chicago IL, Portsmouth NH, San Francisco CA

Printed in the United States of America

Library of Congress Catalog Card Number: 2004108655

For all general information contact Arcadia Publishing at:
Telephone 843-853-2070
Fax 843-853-0044
E-mail sales@arcadiapublishing.com
For customer service and orders:
Toll-Free 1-888-313-2665

Visit us on the Internet at www.arcadiapublishing.com

This book is dedicated to all Redcoats—past, present, and future.

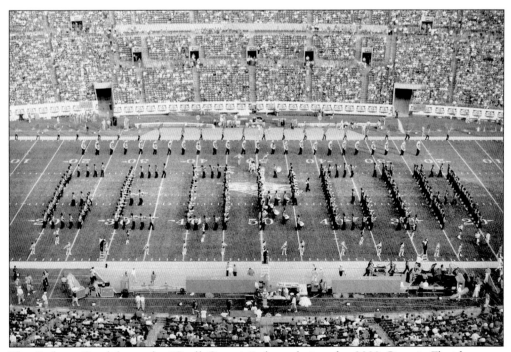

The Redcoat Band forms the "Spell Georgia" cheer during the 2000 Georgia-Florida game. (Redcoat Band Archives.)

CONTENTS

Acknowledgments

I would like to thank the following people without whom this book would not have been possible: Dr. F. David Romines, Dr. John Culvahouse, Dr. David Kish, and Mr. Brett Bawcum, directors of the Redcoat Band; Kristie Sartain, Redcoat Band secretary; and Sylvia Hutchinson, whose assistance made this book possible; Coach Vince Dooley and Coach Mark Richt for their continuous support of the Redcoat program and their kind words at the beginning of this book; the many photographers over the years whose pictures made it into the Redcoat Archives and eventually this book; Chris Cooper, graduate assistant and webmaster for the Redcoat Band, for his pictures of the 2003 season; Andrew Davison, Frank Folds, and Wayne Fears for their histories of the University of Georgia Bands; Dr. Patricia Daugherty, director of UGA Student Activities, for her permission in using the *Pandora* yearbooks; and finally, above all, I would like to thank the Redcoats themselves. For six seasons I have witnessed some of the greatest moments in Georgia football, from Kanon Parkman's last-minute field goal at Tech in 1995 to the overtime thriller against Purdue in 2004. After six years of roller coaster seasons, I have never been more proud to be a member of the finest marching band in the land. Here's to the first 100 years, and let's hope the next 100 years will be just as exciting.

Robin J. Richards

FOREWORD BY VINCE DOOLEY

I have often said that the Redcoat Band is the heartbeat of the Bulldog spirit for our football fans and the fans of all of our sports teams. For 25 years I had the great privilege of running into Sanford Stadium between the Hedges as the band played "Glory Glory to Old Georgia." What was perhaps even more special in a more personal way was that each year when the band came back early to prepare for the opening game, they always put on a special rehearsal of the halftime show for me and the team under the lights of the old practice field the Thursday night prior to the first game of the season. Afterwards I had the privilege of speaking to the band to thank them for all of their hard work and to let each of them know how much we appreciate their great contribution to the university and to Georgia athletics.

The Redcoat Band and all of its members will always have a special place in my heart as I reflect on the many wonderful memories of my 40-year experience at Georgia.

Vince Dooley
Head Football Coach 1964–1989
UGA Athletic Director 1979–2004

FOREWORD BY MARK RICHT

The Georgia Redcoat Marching Band has had a tremendous impact on me in the three short years I have been at Georgia. I can recall every July and August when our players come into town to begin two-a-day practices that the band is also there. I can guarantee that I can point out the band to our players and let them know that they are not the only ones working hard to get ready for the season. As a matter of fact, I think the Redcoat Band probably practices longer and harder than we do.

To hear the band at all of our games, especially at our away games, reminds us that we have a friend in hostile territory. I admire the work that it takes to get the job done, and no one does it better than the Georgia Redcoat Marching Band!

Mark Richt
Head Football Coach

SOURCES

Cooper, Chris. Webmaster, UGA Bands Website. <www.uga.edu/ugabands>
Davison, Andrew. "The History of a Major Educational Influence: The University of Georgia Band." August 1962: Athens, Georgia.
Fears, Wayne. "The University of Georgia Band: 1981–1985." July 1985: Athens, Georgia.
Folds, Frank. "The University of Georgia Band: 1962–1981." June 1981: Athens, Georgia.
The Pandora UGA Yearbook.
The Red & Black UGA Student Newspaper.
University of Georgia Redcoat Band Archives, School of Music.

One

THE FIRST 50 YEARS
1905–1955

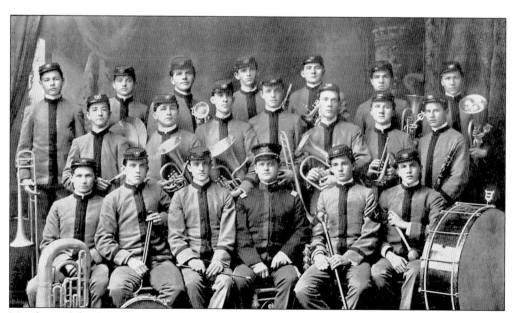

Members of the first Georgia Military Band pose for the 1906 *Pandora* yearbook. Consisting of members of the UGA military corps (a forerunner of the ROTC), many of whom had never played an instrument in their lives, the band was led by R.E. Haughey (first row, third from left). Seated to Haughey's left is Maj. James Kimbrough, PMST (Professor of Military Science and Tactics), the man whose efforts led to the creation of the Georgia Band.

The first "band room" for the Georgia Band was located on the first floor of New College on North Campus (above). Built in 1823 as a classroom and dorm, it burned down in 1830 and was rebuilt two years later. Used as a dorm and as the Pharmacy School, it now houses the offices of the Franklin College of Arts and Sciences, whose advisement offices occupy this space (below). (Redcoat Band Archives.)

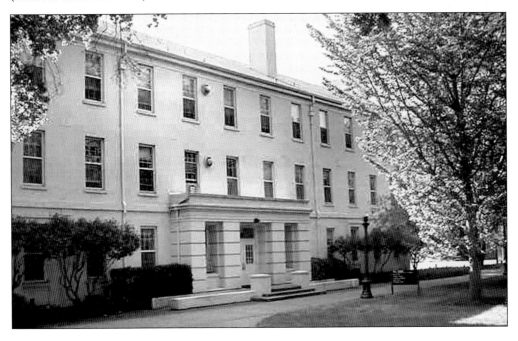

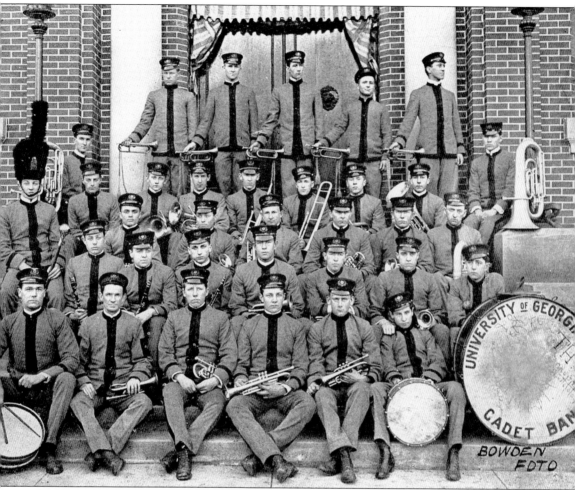

By 1910, the year this photo was taken, the band had grown modestly in size, with 34 band members in this picture. Note the letters "THWT" written on the bass drum—"To Hell with Tech"—and the lackadaisical pose of the snare drummer. The cadets standing in the last row are all buglers. (Redcoat Band Archives.)

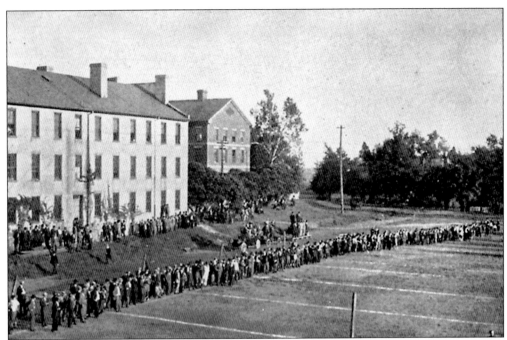

Herty Field, located between New College and Candler Hall, was the official football field for the Georgia team from 1892 to 1911. Members of the band were known to come out and play their horns to cheer on the team, so much so that one writer for the *Atlanta Journal* complained about the "incessant" playing of "John Brown's Body," not knowing it was the school's new fight song, "Glory Glory to Old Georgia," which was arranged in its current form by Hugh Hodgson, future head of the School of Music, in 1915. In the 1930s Herty Field was turned into a parking lot, but it was reconverted to green space in 1999 (below). (1911 *Pandora* Yearbook.)

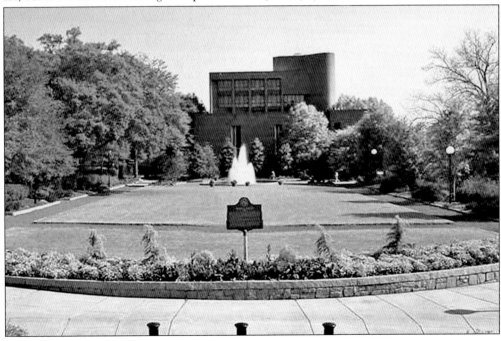

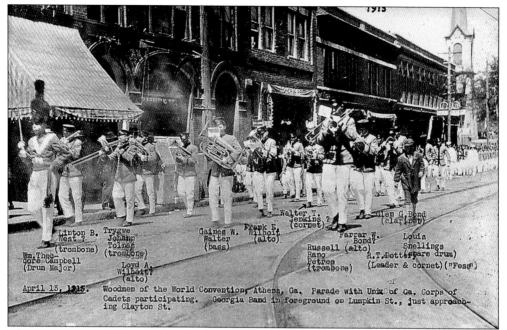

The steeple in the background is that of the
First Methodist Church of Athens, and the buildings alongside are now the sites of the Georgia
Theatre. (Redcoat Band Archives.)

The UGA Cadet Band (with identifying captions of the members) leads the Woodmen of the
World's parade down Lumpkin Street in 1915. The steeple in the background is that of the
First Methodist Church of Athens, and the buildings alongside are now the sites of the Georgia
Theatre. (Redcoat Band Archives.)

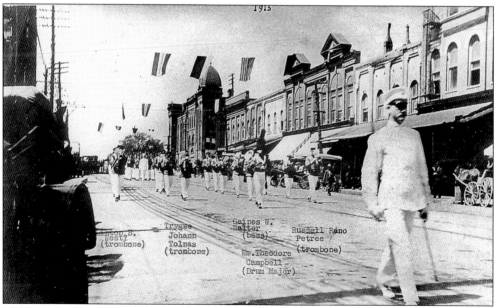

UGA Cadet Band members march down Clayton Street in the Woodmen of the World's
parade in 1915. The building behind the cadet captain, in the white outfit, is the site of the
Transmetropolitan Restaurant. The twin triangles in the building to the left are the current
sites of Aurum Studios and Lamar Lewis Shoe Company. (Redcoat Band Archives.)

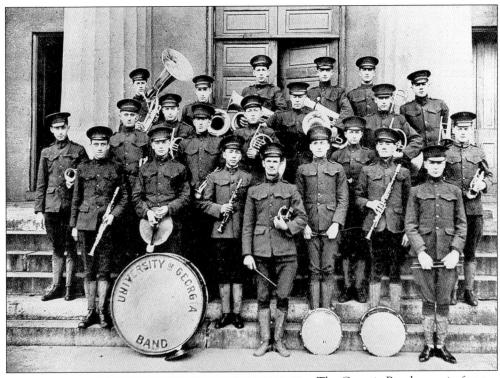

The Georgia Band poses in front of the UGA Chapel for the 1916 *Pandora*. Note the E-flat clarinet (first row, third from left). The band member holding the Helicon bass (a forerunner to the sousaphone, in the upper left corner) is Gaines Walter, who composed the song "Hail to Georgia," often played after a PAT (point after touchdown.)

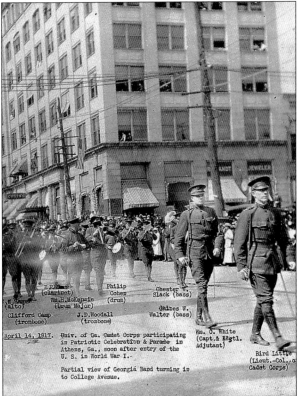

E. Pittman (clarinet)
Philip Cohen
Chester W. Slack (bass)
W. Mayor (alto)
Wm. H. McKenzie (Drum Major)
(drum)
Clifford Camp (trombone)
J. D. Woodall (trombone)
Gaines W. Walter (bass)

April 14, 1917. Univ. of Ga. Cadet Corps participating in Patriotic Celebration & Parade in Athens, Ga., soon after entry of the U. S. in World War I.

Partial view of Georgia Band turning in to College Avenue.

Wm. O. White (Capt. & Regtl. Adjutant)

Bird Little (Lieut.-Col., of Cadet Corps)

In 1917 the band marched in the "Patriotic Celebration and Parade," held on April 14, just 12 days after America entered World War I. Here the band marches down College Avenue towards the Arch. The building in the background is the Commerce Building, whose lower floor is now occupied by Southtrust Bank. (Redcoat Band Archives.)

Gaines Walter (at left), the assistant leader of the Georgia Band, talks with Director Robert "Fess" Dottery (at right) at the UGA encampment held in Gainesville, Georgia, in April 1917. In the background is Pvt. John Tabor, a baritone player. (Redcoat Band Archives.)

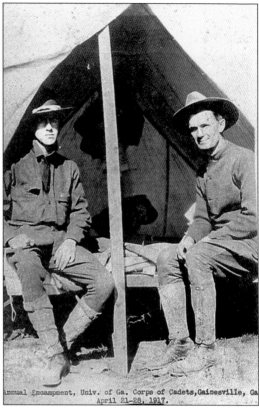

Annual Encampment, Univ. of Ga. Corps of Cadets, Gainesville, Ga
April 21-28, 1917.

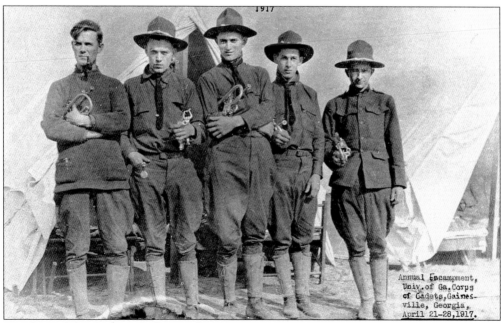

1917

Annual Encampment,
Univ. of Ga. Corps
of Cadets, Gaines-
ville, Georgia,
April 21-28, 1917.

Members of the Georgia Cadet Band coronet section pose in front of their tent at the annual encampment in April 1917. Members are, from left to right, Fess Dottery, J.D. Johnson, Jessie James Benford, J.J. Evans, and H.C. Daley. (Redcoat Band Archives.)

15

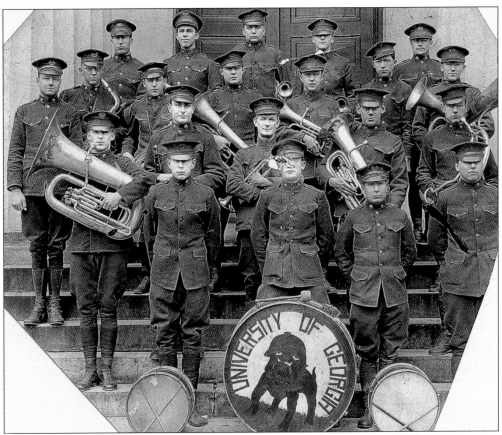

The Georgia Band poses for this 1923 *Pandora* picture in front of the UGA Chapel. Note the saxophone in the third row, far left (player with glasses) as well as the bulldog and his choice of headgear on the bass drum in the foreground.

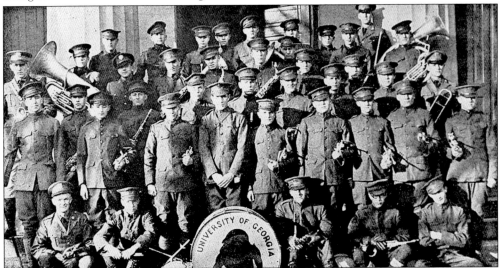

The 1927 Georgia Cadet Band poses in front of the UGA Chapel for their *Pandora* picture. Bandleader R.T. "Fess" Dottery can be seen in the front row at far left.

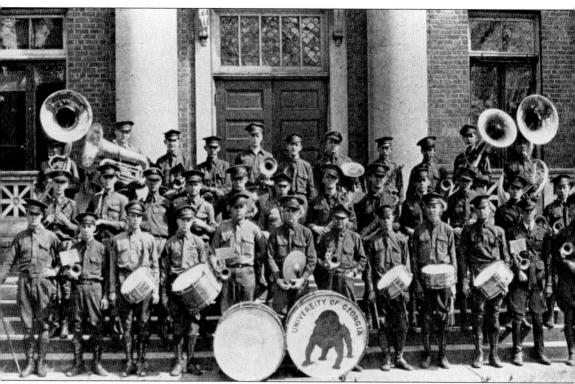

In 1929 sousaphones were added for the first time to the Georgia Cadet Band, as seen in this *Pandora* picture taken in front of Peabody Hall on North Campus. (1929 *Pandora* Yearbook.)

This photo, taken at a halftime show in 1931, is the first known photo of the band in a uniform that was not associated with the military corps. At this time, the uniform consisted of black pants and coat with a red cape. (Redcoat Band Archives.)

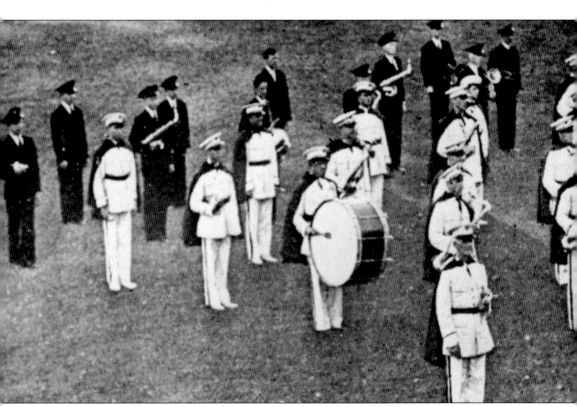

The Georgia Band poses for their *Pandora* picture during the 1933–1934 school year. Note the different colored uniforms of the members in the back. Due to a small increase in membership,

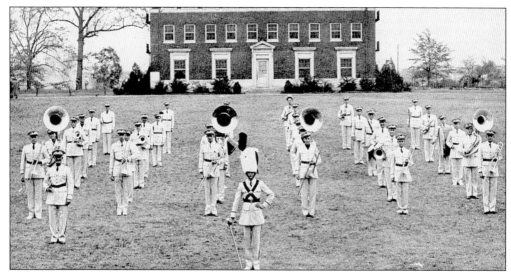

The Georgia Band is pictured here in 1935. During the LSU game that year, Huey Long sent the 150-member LSU "Golden Band from Tigerland" to Athens, prompting several people to pressure the Athletic Association and the Military Department to bring in more players. As a result, 78 people joined the band the following year. This photo was taken in front of Milledge Hall on what is now called the Reed Quad. (1935 *Pandora* Yearbook.)

there were not enough of the new red-and-white uniforms to go around.

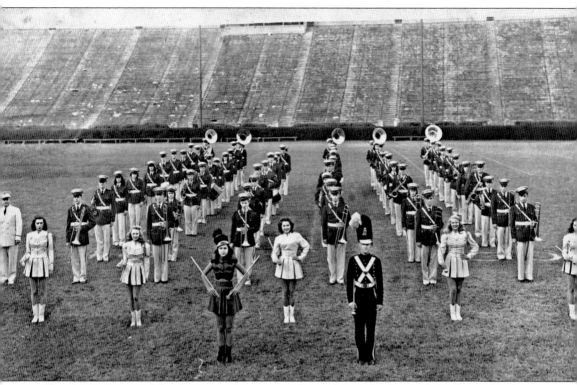

The 1948 Georgia Marching Band poses on the field inside Sanford Stadium. (Redcoat Band Archives.)

Two

THE SECOND 50 YEARS
1955–2005

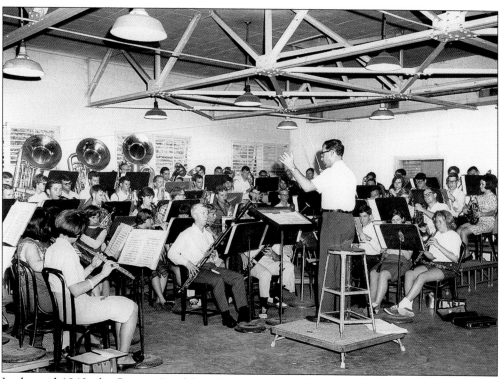

In the mid-1940s the Georgia Band found a new home at Stegeman Hall, named for the former Georgia football coach. Built by the navy during World War II for their pre-flight program, the band room was housed in the former pistol range and shared space with the uniform closet for the ROTC program. (Redcoat Band Archives.)

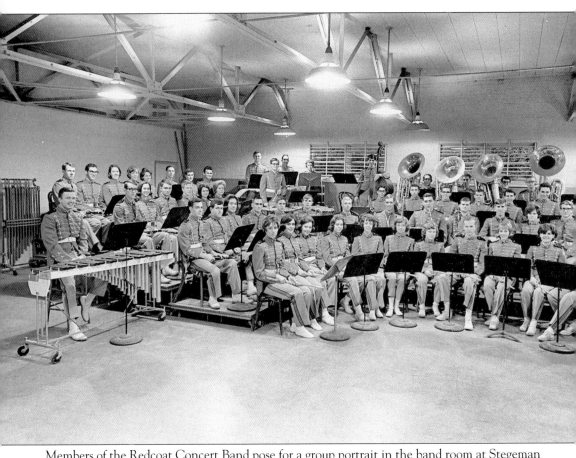

Members of the Redcoat Concert Band pose for a group portrait in the band room at Stegeman Hall. The man in the white jacket on the far right is Roger Dancz, band director from 1955 to 1991. (Redcoat Band Archives.)

The size of the band and Stegeman's Band Room forced the photographer to take two pictures. While they are dressed in the marching band uniforms, this is actually the band that performs indoors during the off season. (Redcoat Band Archives.)

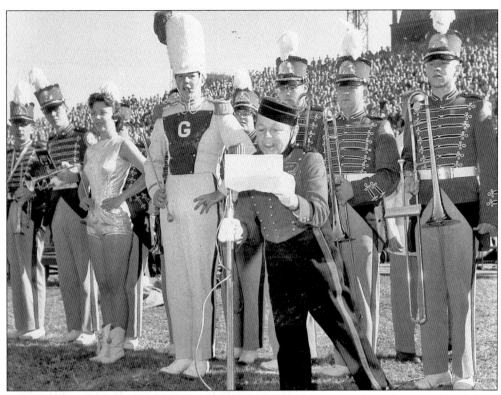

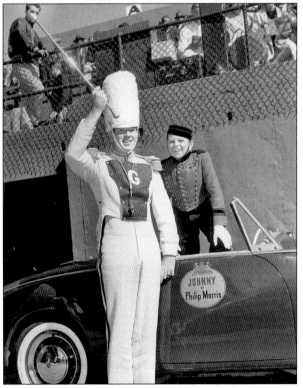

On October 18, 1959, the Dixie Redcoat Band was invited to perform at halftime during the Washington Redskins–Pittsburgh Steelers game in Washington, D.C., as part of "Georgia Day," which was sponsored by Phillip Morris. Here Johnny Phillip Morris (born Johnny Roventini) introduces the 130-member band during halftime. "Georgia Day" was part of Phillip Morris's "Days of Dixie" feature, which was aired nationally on NBC. (Redcoat Band Archives.)

Redcoat drum major Cleve Miller of Elberton poses with Johnny Phillip Morris at the "Georgia Day" ceremony in 1958. While the fans enjoyed the halftime show, the same could not be said for the game: Washington lost 27-6. (Redcoat Band Archives.)

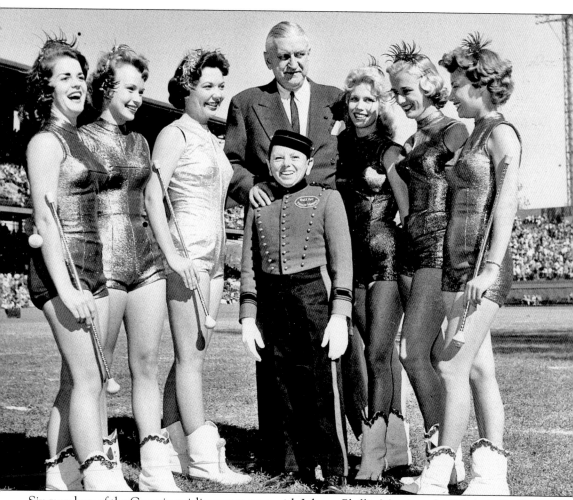

Six members of the Georgia twirling corps pose with Johnny Phillip Morris at the "Georgia Day" program during the 1958 Washington Redskins–Pittsburgh Steelers game. From left to right are Jane Smith, Judy Fox, Barbara Emminger, George Marshall (president of Phillip Morris,) Lola Kimbrel, Nan Heston, and Jennie Wren. (Redcoat Band Archives.)

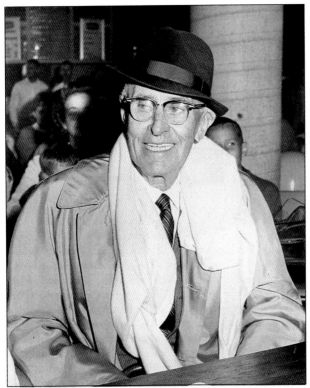

Judge Frank Foley was made an honorary member of the Redcoat Band in 1958 for his fund-raising efforts by writing to 125 of his closest friends, including head football coach Wally Butts, and asking them to send $80, the cost of a new uniform. In the end he raised over $10,000 and was also the benefactor of new parade drums to the band in 1956. A former baseball player at Georgia, the baseball stadium is named in Judge Foley's honor (below.) (Redcoat Band Archives.)

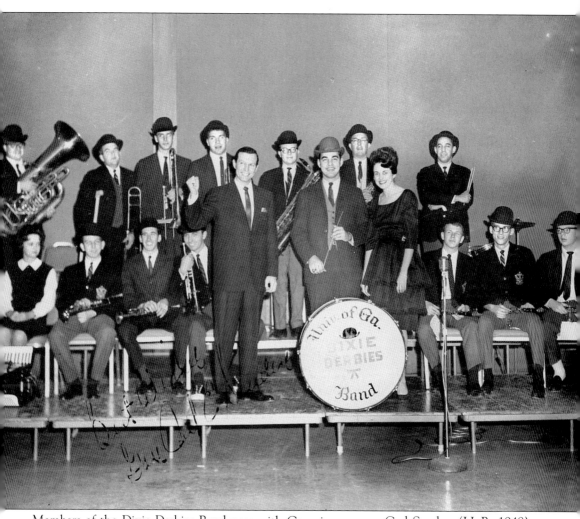

Members of the Dixie Derbies Band pose with Georgia governor Carl Sanders (LL.B.–1948) (with hand clenched in the air) in 1958. Formed as a smaller band that travels to games when the entire band is unable to attend, the Derbies normally travel to Kentucky, Vanderbilt, LSU, Arkansas, and any other games where distance is a factor. Note the autograph by Governor Sanders. (Redcoat Band Archives.)

Formed in 1955 by Phyllis Dancz, director of the auxiliary corps and wife of Redcoat Band director Roger Dancz, the Georgettes are the dance team for the Redcoat Band. Consisting of highly talented dancers, the team adds its own visual aspects to the halftime shows using props and elaborate choreography. (Redcoat Band Archives.)

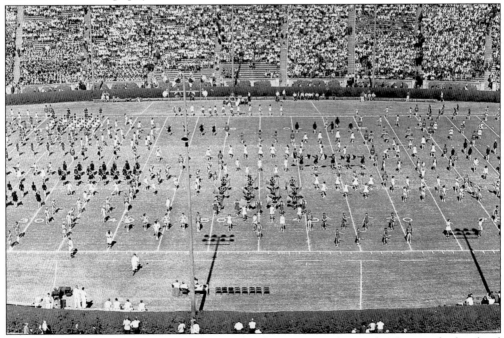

Used as a recruiting tool for the Redcoats, Band Day was a chance for Georgia high-school bands to practice and perform with the Redcoats in Sanford Stadium during the Band Day game. This particular Band Day was in 1961. (Redcoat Band Archives.)

Long considered a tradition among members of the Redcoat Band, two majorettes pose with Uga I, the school's white English bulldog mascot, during the 1961 football season. (Redcoat Band Archives.)

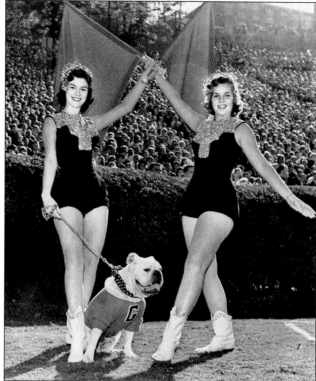

The Dixie Redcoat Band forms the "U of G" formation in November 1962. By this time the Redcoats slowly began replacing marching up and down the field with elaborate drill designs to accompany the music. (Redcoat Band Archives.)

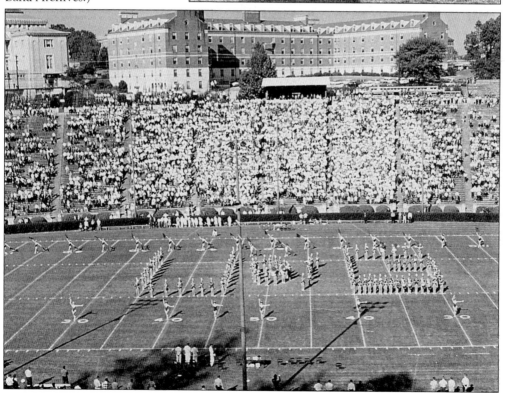

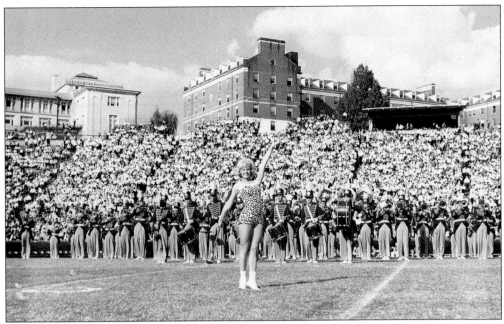

Betty Ann Epperson, the solo twirler, prepares to lead the band onto the field during the 1963 season. In the background can be seen Memorial Hall and Reed Hall (left and right, respectively). (Redcoat Band Archives.)

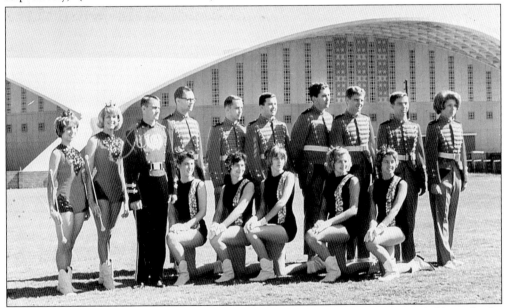

Members of the Redcoat Band Officer Corps pose on the athletic practice fields with the newly completed coliseum (now called Stegeman Coliseum) in the background. Shown here, from left to right, are (kneeling) Karyl Arn, Rima Ford, Paula Cooley, Mary Francis Karwisch, and Rhea Rhodes; (standing) Marsha Newton, Bickie Rutherford, Drum Major Eddie Peede, Derik Clackum, Horace Fleming (former president of the University of Southern Mississippi,) Albert Plunkett, Larry McLure, Lewis Foster, Mike Gerschefski, and Connie Barber. (Redcoat Band Archives.)

Two Redcoat flag twirlers pose in front of the newly opened Creswell Hall in 1966. (Redcoat Band Archives.)

On the reverse side of this 1966 promotional postcard created by REM Studios in Athens—who were at the time the official photographers for the Redcoats—the band is listed as an "incomparable" organization. (Redcoat Band Archives.)

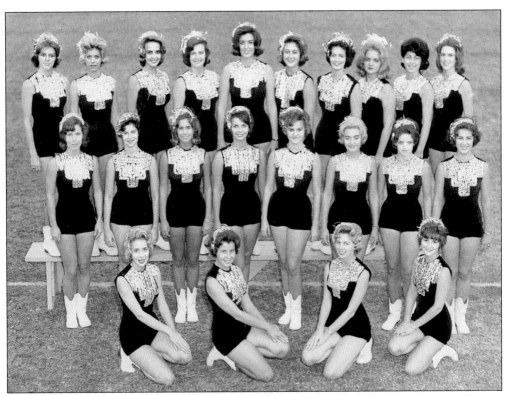

Members of the 1969 Georgia "Go Girls" pose for their group photo. Formed in 1967 by Phyllis Dancz, they were select members of the auxiliary units who performed at halftime and time-outs at Georgia basketball games. Today the Red Hotz and the Dance Dawgs fill these roles, with some of their ranks consisting of members of the auxiliary units. (Redcoat Band Archives.)

In 1961 Joseph Schwartz painted his "Member of the Dixie Redcoat Band" for the Southeastern Art Exhibition in Atlanta, where it won an honorable mention. The model for the painting is unknown, as are the current whereabouts of the painting itself. (Redcoat Band Archives.)

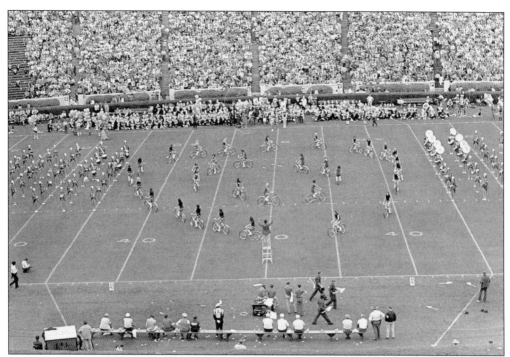

During the 1970s the Redcoats were known for some of their innovative halftime shows incorporating colorful props. Here bicycles ride in a circle on the field at Sanford Stadium during the "Six Flags" show in 1977. (Redcoat Band Archives.)

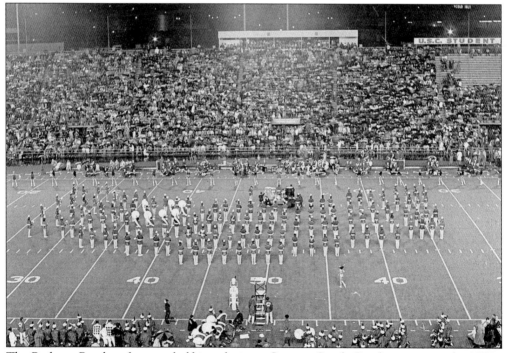

The Redcoat Band performs at halftime during a Georgia–South Carolina game in the 1970s. (Redcoat Band Archives.)

One of the many memorable shows for the Redcoats was the "Wizard of Oz" show in 1977. Here members of the band dressed up as the main characters and acted out the movie on the field while the band played the music. (Redcoat Band Archives.)

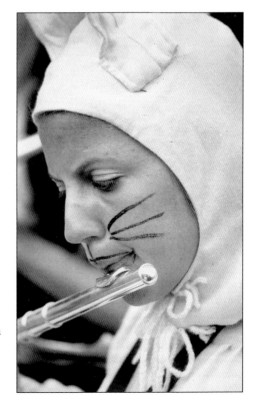

In 1978 the band performed a special Halloween Show on October 31, with each player dressed in his or her own costume. Here a flute player, dressed as a rabbit, performs during the show. (Redcoat Band Archives.)

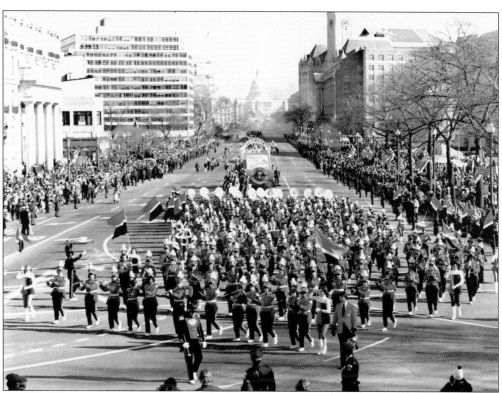

In January 1977 the Redcoats were invited to march in the Inaugural Parade of President Jimmy Carter. They were one of two bands from Georgia—the other being the Americus High School Band—to perform for their native son. (Redcoat Band Archives.)

As a way of saying thank you to the band, the White House sent a letter of gratitude signed by President Carter. (Redcoat Band Archives.)

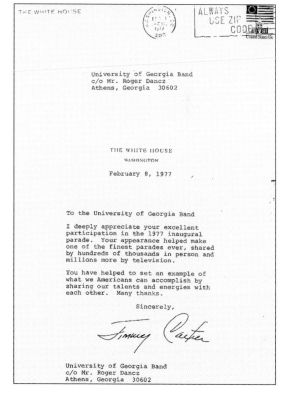

THE WHITE HOUSE

ALWAYS
USE ZIP
CODE

University of Georgia Band
c/o Mr. Roger Dancz
Athens, Georgia 30602

THE WHITE HOUSE
WASHINGTON

February 8, 1977

To the University of Georgia Band

I deeply appreciate your excellent participation in the 1977 inaugural parade. Your appearance helped make one of the finest parades ever, shared by hundreds of thousands in person and millions more by television.

You have helped to set an example of what we Americans can accomplish by sharing our talents and energies with each other. Many thanks.

Sincerely,

Jimmy Carter

University of Georgia Band
c/o Mr. Roger Dancz
Athens, Georgia 30602

Of the many halftime shows the Redcoats have done over the past 50 years, the wedding show from 1978 is one that people seem to bring up most. In perhaps the most unique halftime show ever designed, the wedding of Mr. and Mrs. Derrick Day of Marietta took place on the 50-yard line at Sanford Stadium during the Georgia-Vanderbilt game. (Redcoat Band Archives.)

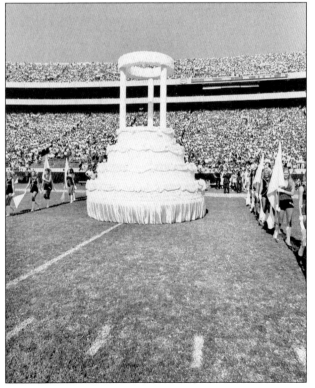

As part of the halftime show during the Georgia-Vanderbilt Homecoming game, a huge wedding cake was placed in the middle of the field. (Redcoat Band Archives.)

With only three minutes to perform the ceremony, the cake was rolled out onto the field as the band began their show. Selections included the "Bridal Chorus" from Wagner's *Lohengrin* and the *Wedding March* composed by Felix Mendelssohn. (Redcoat Band Archives.)

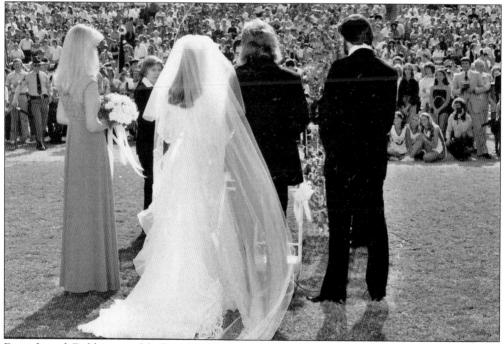

Derrick and Debbie stood before 55,800 fans to take their vows. Selected from hundreds of applicants, Derrick was contacted but had no interest anymore in taking part. Unbeknownst to him, his future wife also applied, and when she was contacted, she accepted the invitation. (Redcoat Band Archives.)

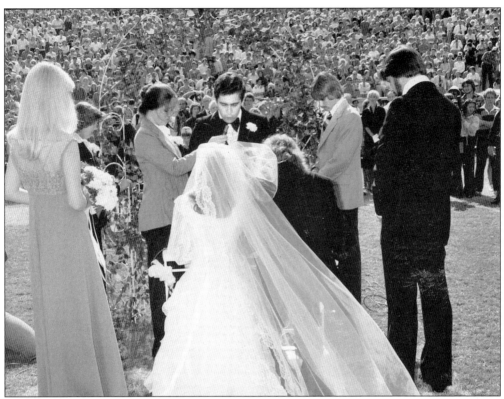

The wedding ceremony was originally part of a larger promotion for the film *A Wedding*, starring Desi Arnaz Jr. and directed by Robert Altman. The Hollywood promotion fell through but the wedding went on as planned. (Redcoat Band Archives.)

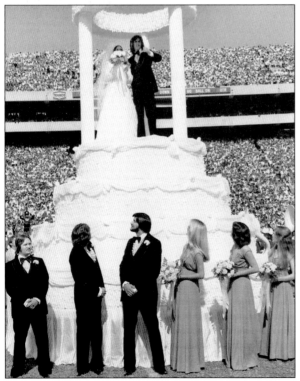

At the end of the three-minute ceremony, the couple climbed up on the cake and was introduced for the first time as Mr. and Mrs. Derrick Day. (Redcoat Band Archives.)

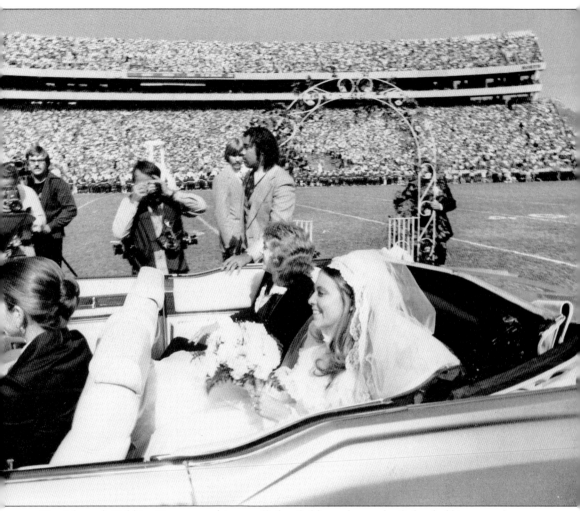

Derrick and Debbie Day were driven off the field at the end of the halftime ceremony. Everything for the wedding, from the dresses to the flowers to the cars, was donated by Athens-area businesses. Even the honeymoon, an overnight trip to Lake Lanier, was donated. (Redcoat Band Archives.)

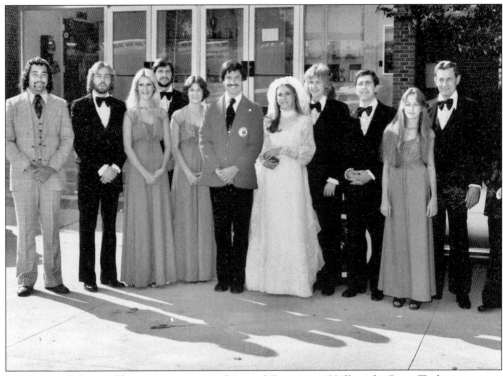

Members of the wedding party pose in front of Stegeman Hall with Gary Teske, assistant director of the band (center.) (Redcoat Band Archives.)

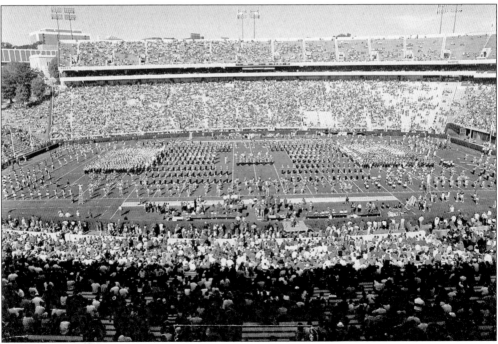

Continuing the tradition begun in the 1930s, hundreds of Georgia high-school bands attend the annual Band Day festivities in 1987. (Redcoat Band Archives.)

When the Redcoats travel to Auburn to play the Tigers, they never know what will happen at the South's oldest rivalry. In 1986, after Georgia upset Auburn 20-16, the Georgia fans began to storm the field, prompting the Auburn police to use the field's sprinkler system as a water cannon directly in front of the band section. (Redcoat Band Archives.)

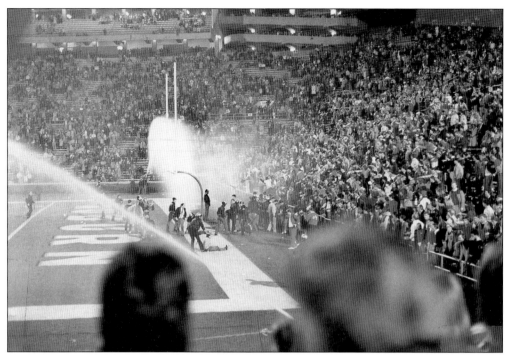

As the Redcoats look on, fans who managed to run out onto the field at Jordan-Hare Stadium are promptly subdued by the Auburn police and their water cannon.

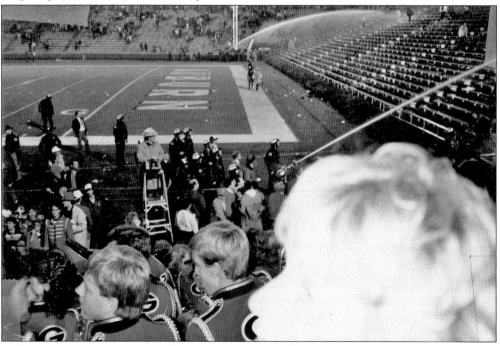

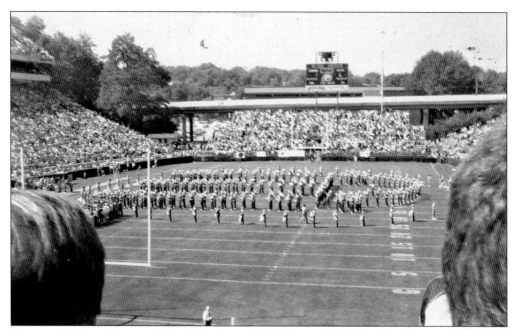

As part of the bicentennial celebration of UGA in 1985, the band incorporated the Arch, hallowed symbol of the school and the state, into their pre-game show. Today the band begins their pre-game show with this symbol. Note the northwest and southwest corners of the end zone are not filled in with seats; they would not be installed until 1991. (Redcoat Band Archives.)

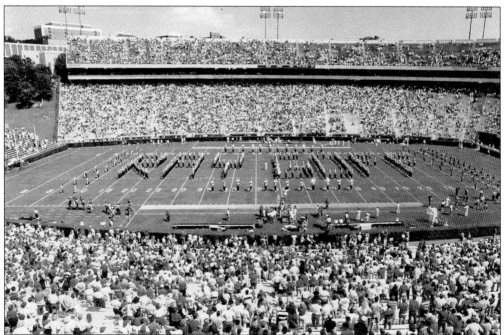

In 1989 Georgia welcomed a new coach, Ray Goff. In a change from tradition, the Redcoats welcomed him by spelling out his name on the field during pre-game during the opening game against Baylor (Georgia won 15-3). (Redcoat Band Archives.)

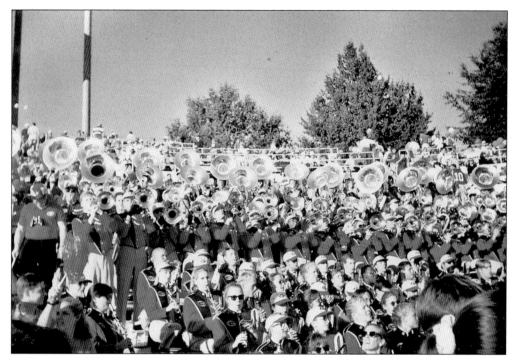

In the fall of 1995 the Redcoats introduced a new logo and the first all-new uniforms since 1958, which consisted of two pants (gray and black) and a reversible black and silver cape. This same uniform is still worn today, although the black pants are the only pants used. These pictures are from the debut of the new uniforms at the Georgia-Clemson game in 1995 (Georgia won 19-17). (Author's collection.)

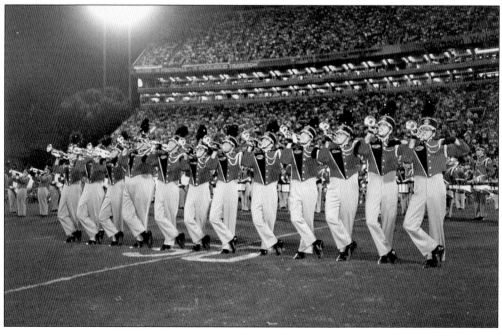

One of the annual spring commitments of the Redcoats is their performance at the annual G-Day scrimmage. Usually held in April, the game is a charity fund-raiser for such groups as the United Way. In a rare departure from uniforms, members get to play in T-shirts and jeans, as seen in here at the 1997 G-Day game. (Author's collection.)

At the conclusion of the 1998 Outback Bowl in Tampa, quarterback Mike Bobo (left, now QB coach under Mark Richt) and Robert Edwards (below, former RB for New England and Miami) conducted the Redcoats after Georgia's 33-6 win over Wisconsin, led by future Heisman winner Ron Dayne. (Redcoat Band Archives.)

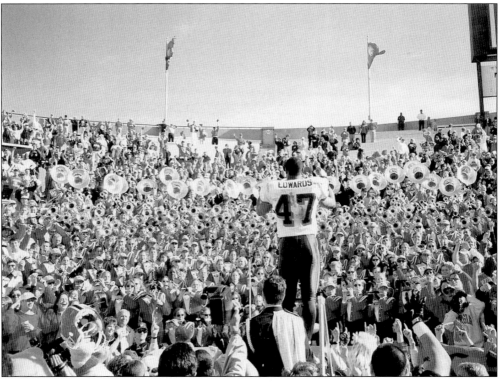

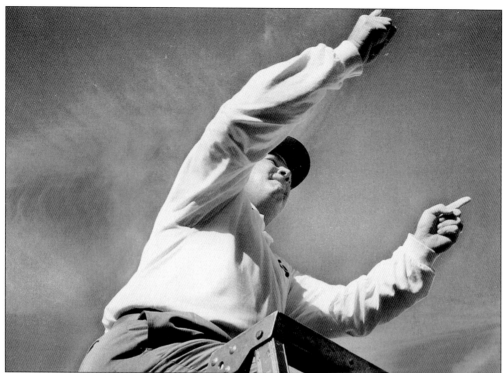

Head football coach Jim Donnan conducts the Redcoats after the victory in the 1998 Outback Bowl in Tampa. Georgia ended the season with a 10–2 record and a number-10 ranking in the polls.

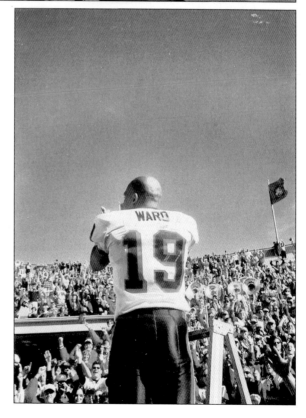

Georgia football player Hines Ward—currently with the Pittsburgh Steelers—conducts the band after the Bulldogs' win at the 1998 Outback Bowl.

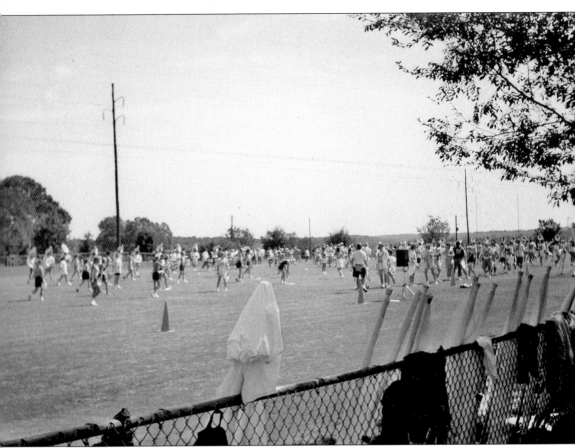

Members of the band arrive two weeks before school starts to learn marching basics and drill for the pre-game and first halftime show of the season. Band Camp practices, which run from 9:00 a.m. to 9:00 p.m., normally take place at the intramural fields off College Station Road. (Author's collection.)

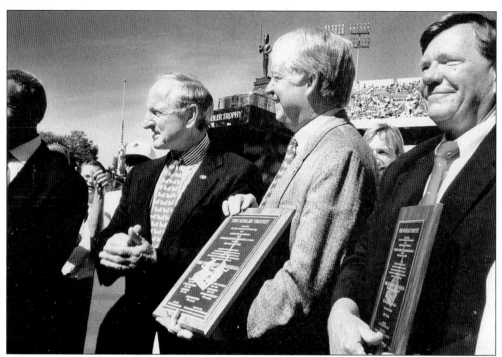

In 2000 the Redcoats became the first SEC band to be awarded the Sudler Trophy for being the best collegiate band in America (below right). In an on-field ceremony at the Homecoming game (above), the trophy, nicknamed "the Heisman for marching bands," was formally presented. Hundreds of Redcoat alumni were invited onto the field as, from left to right, athletic director Vince Dooley, UGA president Dr. Michael Adams, and Redcoat Band director Dr. Dwight Satterwhite pose with the plaques honoring the best band in America. (Redcoat Band Archives.)

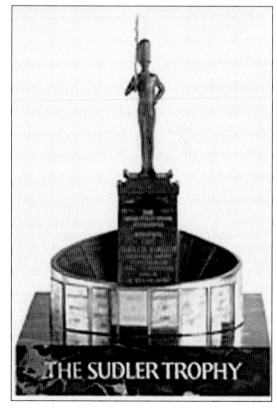

At the end of the pre-game show, the band forms a tunnel to announce the arrival of the football team. In past seasons a campus organization used to sponsor a paper banner for the team to run through. Currently, the team runs through a large, fabric "Super G" banner that is Velcroed in the middle. This picture is from the pre-game at the 2003 Sugar Bowl (Georgia 26-Florida State 13.) (Author's collection.)

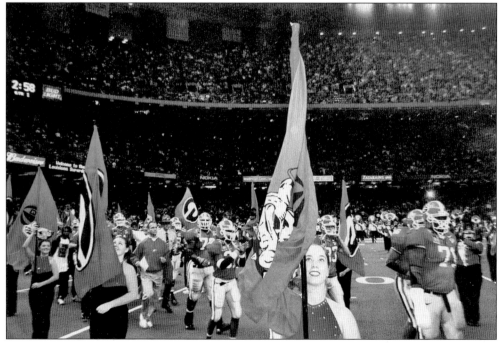

Coach Richt (in front of the Georgia state trooper) runs through the band as they play at the 2003 Sugar Bowl. (Author's collection.)

Every fall for the Homecoming game, members of the Redcoat Alumni Band converge on Athens to take part in the Homecoming festivities. They meet in the early morning hours to rehearse the pre-game show. (Redcoat Band Archives.)

Members of the Redcoat Alumni Band line up on the field to begin their performance of the pre-game show. Some alumni are from the Athens-Atlanta area, while others have traveled from as far away as Japan to take part in this annual tradition. (Redcoat Band Archives.)

Former auxiliary members also perform during the alumni pre-game show. Many members still wear their original auxiliary uniforms for the show. (Redcoat Band Archives.)

Chesley Baxter Cypert, a former Georgette, performs with the Alumni Auxiliary Corps during the Alumni Band pre-game show. (Redcoat Band Archives.)

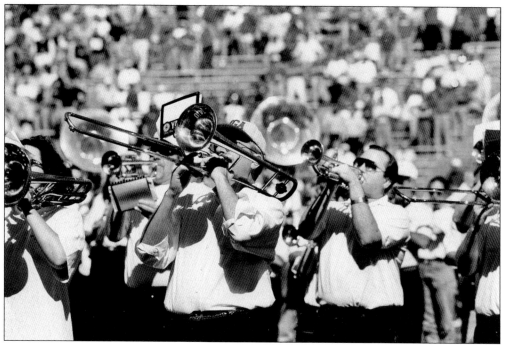

The Redcoat Alumni Band trombone section performs on the field during the alumni pre-game show. (Redcoat Band Archives.)

The Georgia football team runs out onto the field as the Alumni Band plays the fight song. (Redcoat Band Archives.)

Redcoat Band members pose in front of one of the equipment trucks as part of an advertisement for Akim's K-bob, a local restaurant. (Redcoat Band Archives.)

Three

THE DIRECTORS OF THE REDCOAT BAND

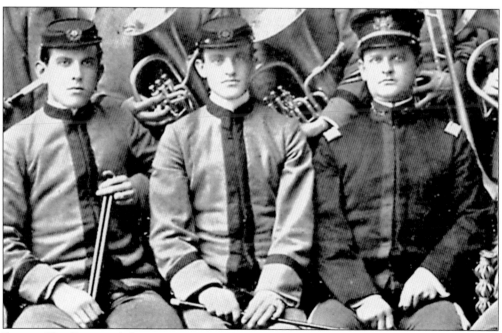

Born in Hot Springs, Arkansas, in 1882, Robert E. Haughey (center) (1905–1909) was the son of amateur musicians. He took violin lessons and decided to form a dance orchestra, coming to Athens around the turn of the 20th century to open a music store. Haughey was the jack-of-all-trades for the band: tutor, repairman, and arranger for several UGA songs, including the first fight song, called "The Red and Black," of which there are no known extant copies. By 1909 his busy schedule between the band and his business took a toll on his health, causing him to resign. He took up farming until his death in 1963.

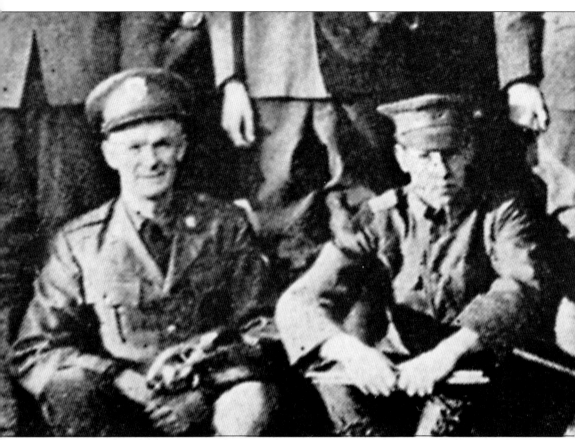

A member of Haughey's dance orchestra, Robert Dottery (right) (1909–1944) was picked as the Georgia Band's second director in 1909. Nicknamed "Fess," Dottery pioneered the printing of arrangements of several well-known UGA songs, including "Glory Glory to Old Georgia." He also introduced the Band Day program at the 1933 UGA-NYU game (GA 25-NYU 0).

J. Harris Mitchell (left) (1944–1955) was hired as Georgia's band director in 1944. An accomplished French horn player, he graduated from Carleton College in 1936 with a degree in music. Before coming to UGA, he served as director of the Greensboro North Carolina High School Band. In 1954 he was made acting director of the music department, and he served in that position until he left to pursue his doctorate from the University of North Carolina.

Hailing from Ludington, Michigan, and a cum laude graduate from Stetson University, where he played trumpet, Roger L. Dancz (1955–1991) arrived in Athens in 1955 after a two-year stint in the U.S. Army bands at Fort Jackson and Fort McPherson. He started with 25 people at his first rehearsal and only six days to the first home game. Over time he and his wife, Phyllis, who was in charge of the auxiliary corps, created the Redcoat Band that is well known today. He remained in his position as director of bands until 1991. Afterwards, he spent his retirement years continuing to host "An Invitation to Jazz" on WUGA-Athens until his death in 1999.

A native of Detroit, Michigan, and a graduate of both Syracuse and Northern Michigan, Gary Teske (1975–1982) arrived in Athens in 1975 when the Redcoat Band began a massive expansion program. A marching band specialist, he began to implement complex drills along with colorful shows to create a new Redcoat Band.

A graduate of the University of Alabama, Dr. H. Dwight Satterwhite (1982–2002) arrived at Georgia in 1982 as assistant director of bands after previously being the director of bands at Valdosta State. After the retirement of Roger Dancz in 1991, Satterwhite became director of bands, a position he held until 2002.

Dr. John Culvahouse (1991–present) is presently the interim director of bands and associate professor of music at the University of Georgia. Prior to his appointment at UGA in 1991, Dr. Culvahouse taught in public schools in South Carolina and Tennessee for 17 years. He holds the Bachelor and Master of Music Education degrees from the University of Tennessee and a Doctor of Musical Arts in Conducting from the University of South Carolina.

Brett Bawcum (2000–present) is the assistant director of bands at the University of Georgia. His duties at the university include design and instructional responsibilities with the Redcoat Marching Band in concert with the other three directors, as well as primary direction of all other athletic bands, including the Derbies and the Basketball Bands. A former Redcoat drum major, he received the Bachelor of Music Education in 1997 and Master of Music in Conducting in 2000, both from UGA.

In 2002 Dr. F. David Romines (2000–present) was made interim director of the Redcoat Band and was named director in 2004. He holds the Bachelor and Master of Music degrees in Music Education from the University of Tennessee and the Doctor of Musical Arts degree from the University of Southern Mississippi. His duties also include instrumental music education courses, undergraduate conducting classes, and student teacher supervision, as well as being the director of the University of Georgia Summer Marching Band Camp.

A native of Hershey, Pennsylvania, Dr. David Kish (2003–present) is an associate director of bands, assistant professor of music, and Franklin Postdoctoral Teaching Fellow at the University of Georgia. He received the Doctor of Musical Arts and Master of Music in Instrumental Conducting and Music Education from the University of North Carolina at Greensboro, and the Bachelor of Music in Music Education from Susquehanna University in Pennsylvania. Dr. Kish teaches conducting and woodwind and brass methods, supervises student teachers, and assists with all areas of the band program.

Four

GAME DAY

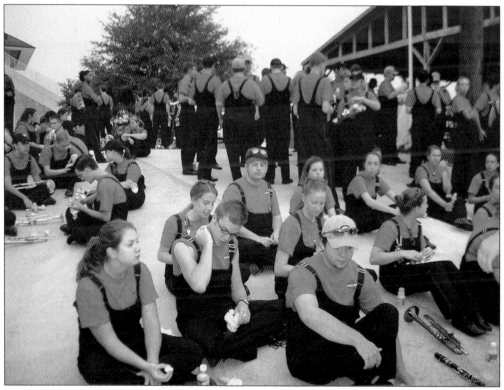

One of the most grueling yet rewarding days in the life of a Redcoat is game day. Whether they play in the familiar confines of Sanford Stadium or travel to hostile territory, the members know that the day will be filled with excitement and (hopefully) a Bulldog victory. Depending on the time of kickoff, the band begins arriving at Woodruff Field for sectionals and breakfast. The first section at every practice is the props crew, who spends their time setting up the field for the morning rehearsal. (Redcoat Band Website.)

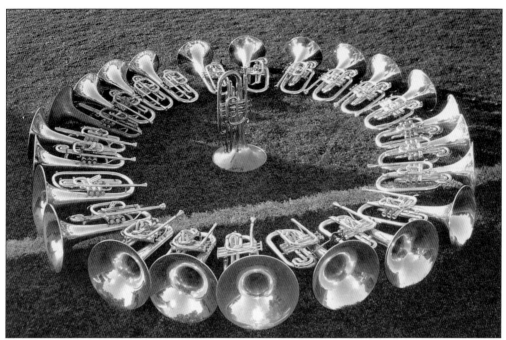

During breakfast most sections find creative ways to display their instruments, as seen here when the mellophone section arranged their horns into a circle as they head off to eat. (Redcoat Band Website.)

After breakfast the band breaks off into sectionals to warm up and to review the music for the pre-game and halftime shows. After an hour-and-a-half rehearsal, the band will perform a final run-through for band parents and interested fans sitting on the hill next to Woodruff Field. (Redcoat Band Website.)

About two hours before kickoff, the drum line assembles in the Tate Student Center parking lot to perform a drum show for the fans who are beginning to assemble. Here members of the snare line play warm-ups as fans line Sanford Bridge in the background. Songs vary from simple warm-ups to the music played at halftime. (Redcoat Band Website.)

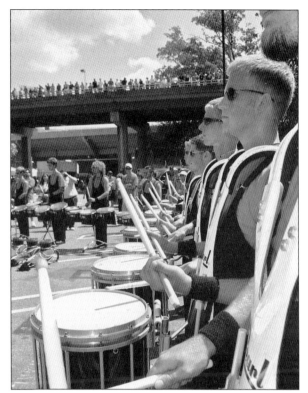

Members of the UGA cymbal line take part in the drum show before the rest of the band shows up for the Tate Center pep rally. (Redcoat Band Website.)

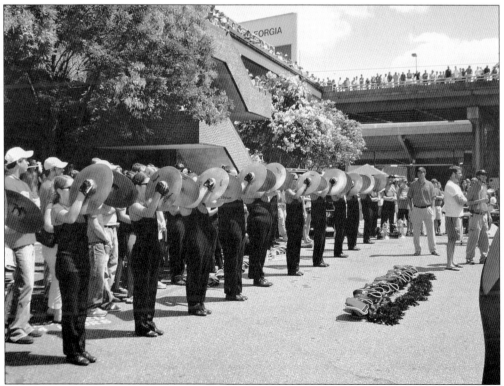

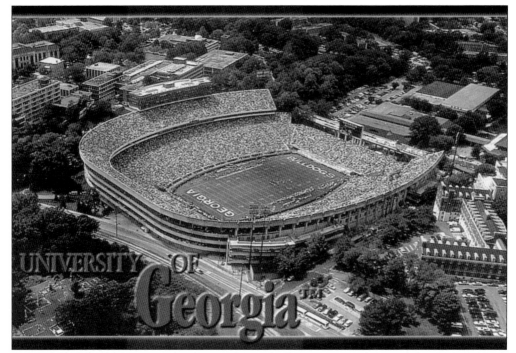

Sanford Stadium, as seen in this postcard, was built in 1929 and named for S.V. Sanford, president of the university at the time of its completion. Originally seating 30,000 spectators at a cost of over $300,000, a recent construction of an upper deck on the north end (right side of the postcard) expanded its capacity to over 92,000, making it the fifth-largest on-campus stadium in the country and the second largest in the Southeastern Conference.

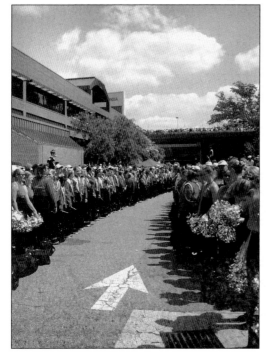

A recent tradition brought back under Coach Richt was the Dawg Walk, in which members of the football team, the coaches, and even the recruits walk through a "path" made by the members of the band. Depending on the team being played, these walks can often be surrounded by thousands of fans cheering the Dawgs to victory. (Redcoat Band Website.)

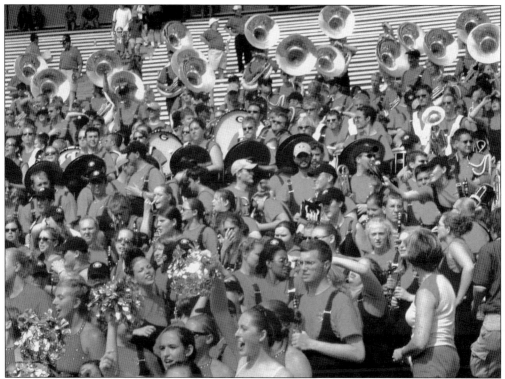

Once finished with pre-game, the band returns to the stands to play. If the temperature in the stadium is high (especially at the early games in August and September), the band takes their wool jackets off in order to stay cool. (Redcoat Band Website.)

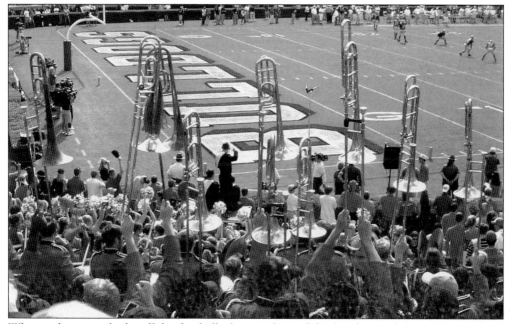

When either team kicks off the football, the members of the band raise their instruments and join with the fans to "call the Dawgs." (Redcoat Band Website.)

Prior to the late 1990s the band occupied a section of the stands on the 30-yard line. In recent years the band has been moved to the northeast corner of the stadium to facilitate faster movement on and off the field. (Redcoat Band Website.)

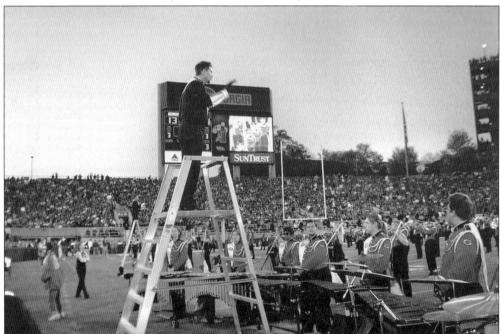

Drum Major Matt Haynor conducts the band on the podium during halftime at the 2003 Georgia-Auburn game. During halftime the drum majors stand on podiums to better direct the band and for the band members to better see them. Often during the show, members of the band can be seen on the stadium's jumbotron in the background. (Redcoat Band Website.)

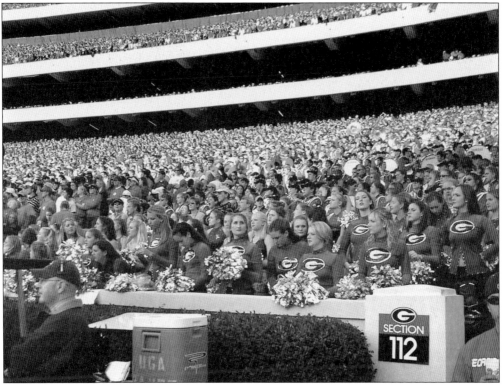

As they must leave the stands early to warm-up and prepare for the upcoming halftime show, members of the Redcoat Band Auxiliaries sit on the first several rows of the band section. (Redcoat Band Website.)

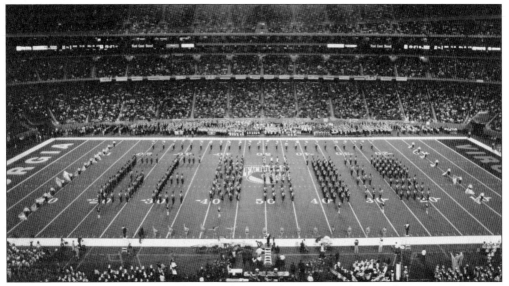

On the most enduring images of any Redcoat performance is the "Spell Georgia" cheer, in which the members of the band form the letters to spell "GEORGIA." The following pictures were taken of the "Spell Georgia" cheer during the 1995 Peach Bowl in Atlanta (Virginia 34-Georgia 27). (Redcoat Band Archives.)

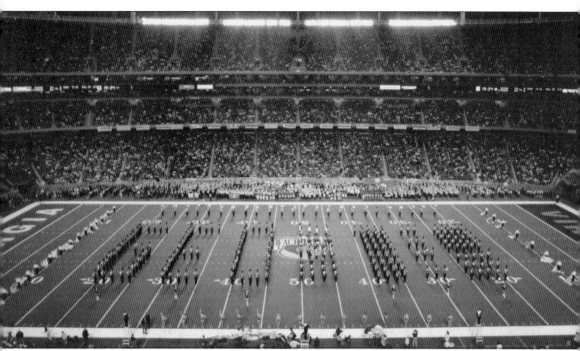

The "Spell Georgia" cheer was the idea of Phyllis Dancz, the auxiliary co-ordinator of the Redcoats, on the way back from a Georgia-Florida game.

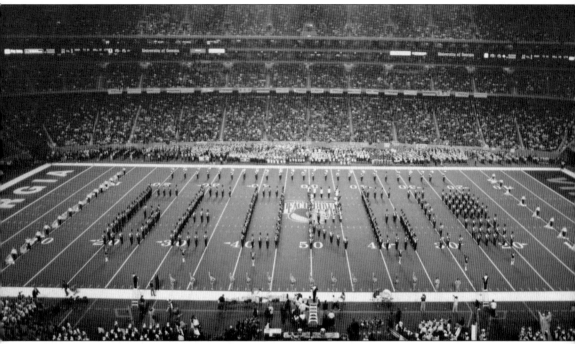

As each letter is formed Tom Jackson, the Redcoat Band announcer, calls for fans to "Give me a G! Give me an E!" and so on until the full word is spelled out.

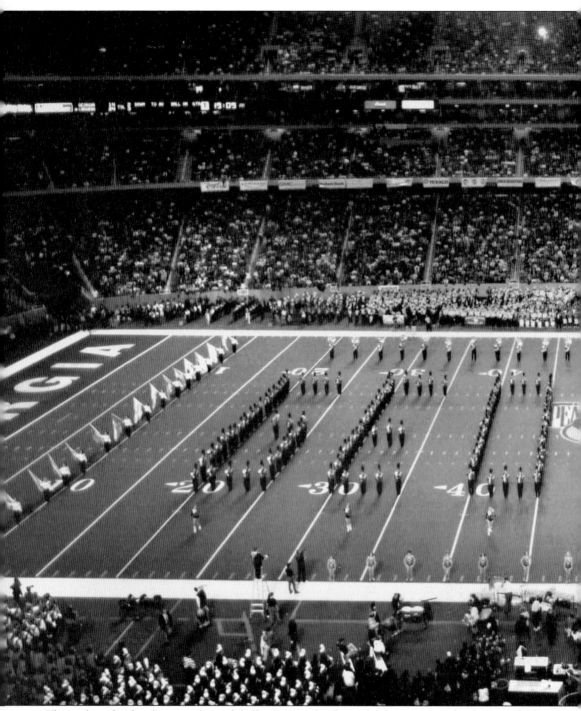

The end result of such a complicated drill is designed to keep the fans' support for the team high

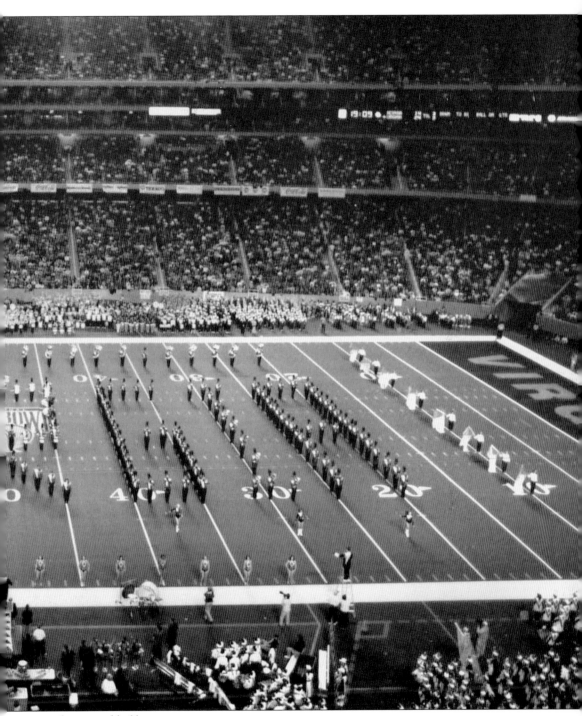

as the second half nears.

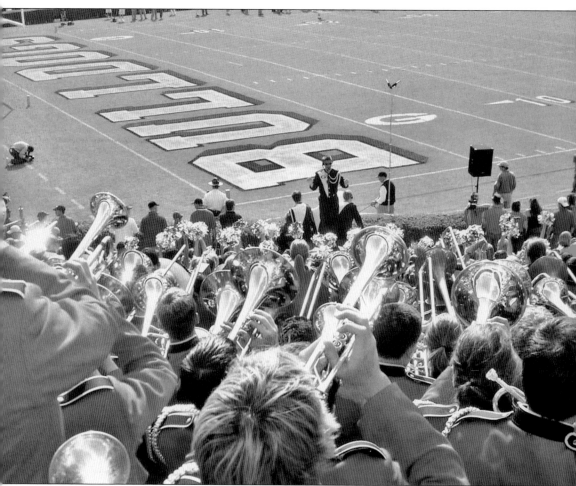

Drum Major Matt Haynor conducts the Redcoats during a time-out. Most music played in the stands consists of various spirit songs from over the last 50 years as well as, on occasion, some more current music. In 2003, after the death of Johnny Cash, the Redcoats honored him by playing "Ring of Fire" to the approval of the surrounding fans. (Redcoat Band Website.)

Drum Major Matt Koperniak conducts the Redcoats during the post-game concert. Win or lose, the Redcoats always perform a post-game concert, designed to both give fans a time to wait while the rest of the stadium empties and for the enjoyment of alumni and fans. When there is a visiting band, the two bands often battle back and forth. (Redcoat Band Website.)

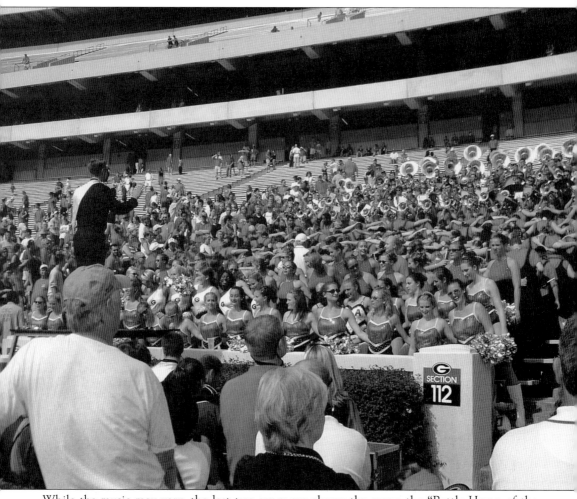

While the music may vary, the last two songs are always the same: the "Battle Hymn of the Bulldog Nation" and "Tara's Theme" from *Gone with the Wind*. Game day officially comes to a close as the band echoes the following sentiment of the Bulldog faithful: "Once a Dawg, always a Dawg . . . how sweet it is." (Redcoat Band Website.)

Five

BAND CAMP

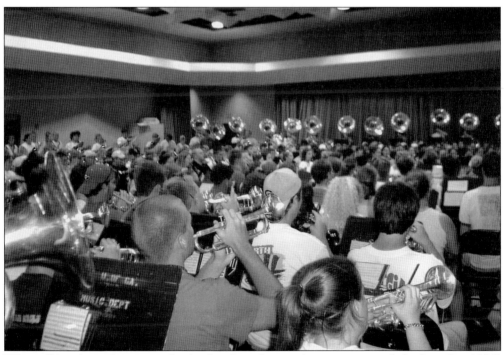

When all band members arrive for the first day of camp, they practice inside Leebern Band Hall to stay out of the searing summer heat. Leebern Band Hall is the first band room built to fit the almost 300 instrumentalists of the Redcoat Band, although sometimes it can be a tight fit. (Redcoat Band Website.)

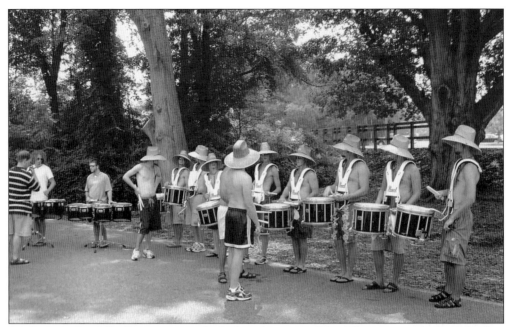

Band camp normally begins two weeks before the start of the fall semester. Among the first groups to show up is the drum line, which spends the first few days learning the warm-ups as well as the halftime show so as to provide a beat for the rest of the band. Here the snare line practices in what little shade they can find (above) while the cymbal line learn their parts to the first halftime show of the season (below). The properties crew, sousaphones, and the auxiliaries also show up early, as their routines often call for longer preparation than the rest of the band. (Redcoat Band Website.)

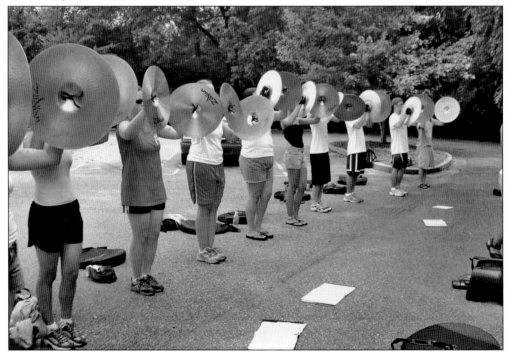

When the band practices outdoors at the intramural fields on College Station Road, the directors need a tower to allow them a bird's eye view of the proceedings. Here Dr. David Romines, director of the Redcoat Band, and Brett Bawcum, assistant director of bands, stand atop their "Sizzor" platform to view practice. (Redcoat Band Website.)

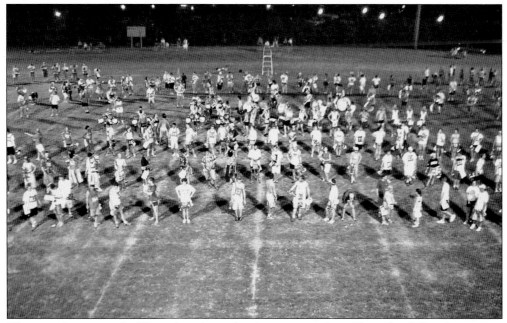

The view from atop the "Sizzor" can give the directors an idea of how the drill is forming on the field. From here, they can also tell which sections and lines need to fall in to make the drill more presentable. (Redcoat Band Website.)

As a way to promote section unity as well as to let off some stress from the long grueling practices, sections often do what is known as a "hype" by dressing up in outlandish outfits. Here the trombone section poses in their "Hawaiian Hype" during the 2003 band camp. (Redcoat Band Website.)

While members of the clarinet section wait for drill in another section to be fixed, members of the UGA flag line continue to practice their complex flag routines. The long hours at the Fields are not without its comical moments, however; whenever a train passes by the band (crossing gates can be seen in the background), the band, as a whole, will turn, face the train, and blow their horns to mimic the locomotive's horn. (Redcoat Band Website.)

In order to organize such a vast number of marching instrumentalists, the Redcoats use a "rank vest" system. Members are given a "rank" that corresponds with their position on the drill charts. This speeds up the process of finding out which rank goes where as well as which rank needs to be moved in order to fit the drill. (Redcoat Band Website.)

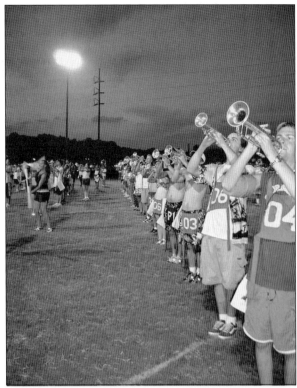

Members of the band finally get a chance to relax during announcements after another long day of practice. The Redcoat Band practices from 9:00 a.m. to 9:00 p.m. five days a week during camp, but the practice hours are reduced once school is in session. The band as a whole practices three days a week, while the drum line and auxiliaries practice an extra day. (Redcoat Band Website.)

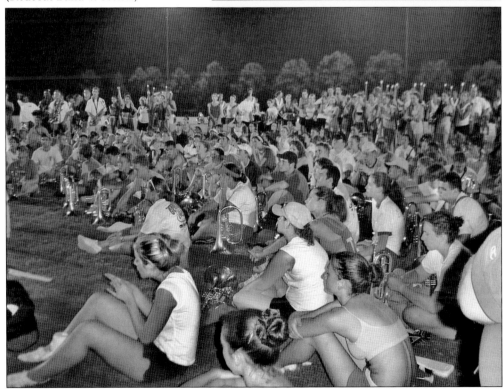

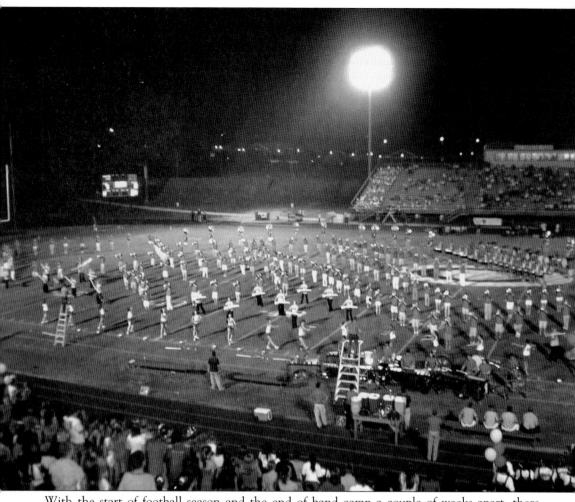

With the start of football season and the end of band camp a couple of weeks apart, there are a few times the Redcoats get to "test" their show in front of a football crowd. In 2003 the Redcoats were invited to perform at halftime at Clarke Central High School in Athens. (Redcoat Band Website.)

Six

REDCOAT SCENES

During the 2003–2004 school year, members of the Redcoat Band formed a team for the annual Relay for Life benefiting the American Cancer Society. The team hosted concerts, held intra-band contests, and capped off the year by attending the all-night relay in April 2004. The Redcoat team created a "jail" where, for $1, someone could be "incarcerated" for 15 minutes. In all, the Redcoats raised over $4,100. (Courtesy Jennifer Burk.)

In 1985 Roger and Phyllis Dancz celebrated their 30th anniversary with the Redcoat Band. As a part of the festivities, a reception was held in their honor at the Georgia Center, attended by Athletic Director Vince Dooley.

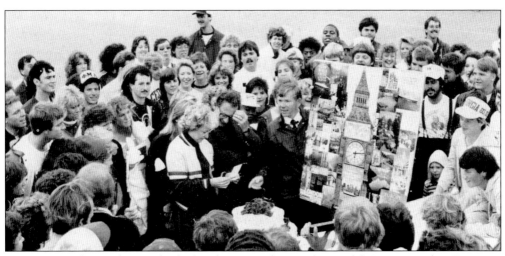

At a practice during that week, the band presented a certificate of deposit towards a European vacation to Roger and Phyllis for their 30 years of dedication to the Redcoat Band.

As part of their fund-raising efforts, the band often raises money to see which member receives a pie in the face. During the Outback Bowl in 2000, Assistant Director Brett Bawcum received this "honor." Filming the outcome is Jim Black, the official videographer for the Redcoat Band. (Redcoat Band Archives.)

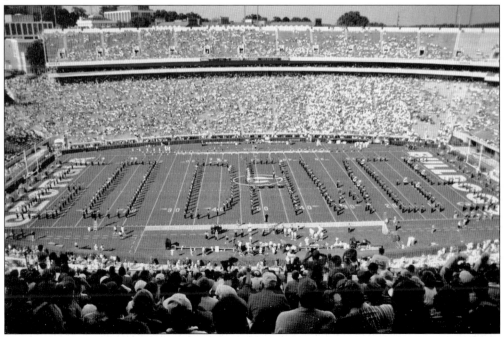

From time to time, the drill for the pre-game show is changed to prevent the show from being the same. Here the band spells out "GO DAWGS" on the field at Sanford Stadium. (Courtesy Brett Bawcum.)

Members of the Redcoat Band flag line pose for a picture after a halftime show in Athens in 1995. (Courtesy Brett Bawcum.)

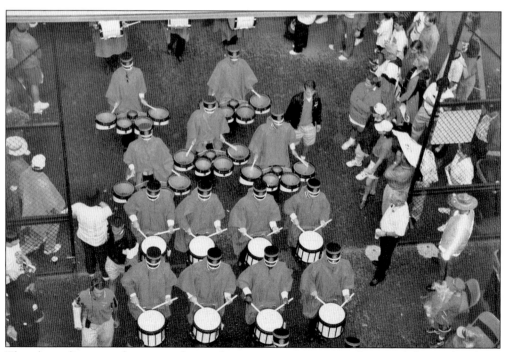

The drum line marches into the stadium on a rainy game day in Athens. (Redcoat Band Archives.)

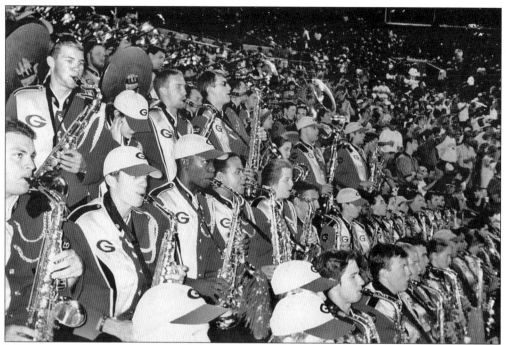

The Redcoat saxophones play in the stands during the 1999 Georgia-Florida game. Note the small black round patches on their shoulders. Upon the passing of longtime Director Roger Dancz, all band members wore the initials "RLD" on their uniforms throughout the season. (Redcoat Band Archives.)

The Redcoat Band practices in the stands of Alltel Stadium just before the 1997 Georgia-Florida game (Georgia 37-Florida 17).

In 1995 the Redcoats marched in the Peach Bowl parade in Atlanta. Later that day in the Georgia Dome, the band performed at halftime and watched a thrilling game as Georgia lost a close one to Virginia 34-27. (Redcoat Band Archives.)

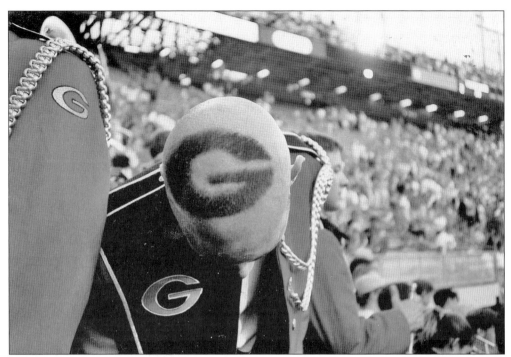

During a football game in Athens, Chris Brown, a member of the Redcoat Band, displays his Bulldog pride by showing the "G" that had been shaved on his head. (Courtesy Brett Bawcum.)

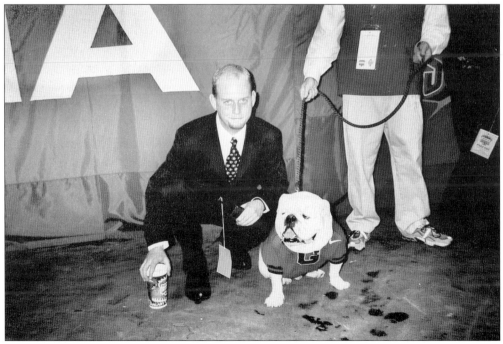

Assistant Director Brett Bawcum poses with Uga VI at the 2003 Sugar Bowl in New Orleans (Georgia 26-Florida State 13). (Courtesy Brett Bawcum.)

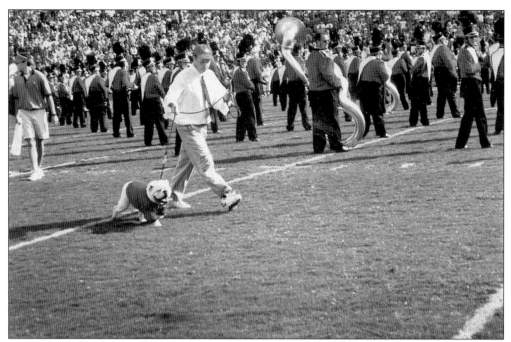

On September 11, 1999, during the pre-game show at the Georgia–South Carolina game, a "changing of the collar" ceremony took place as Uga VI took over for his father, Uga V. Here the new mascot walks onto the field with his handler Charles Seiler as members of the Redcoats look on. (Redcoat Band Archives.)

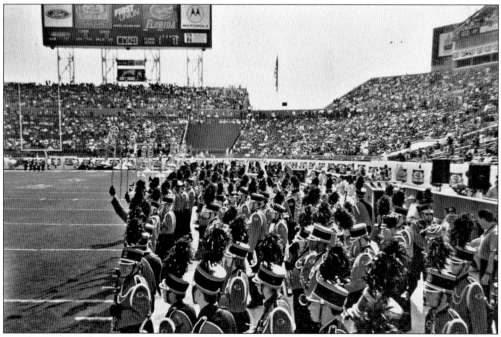

At the start of the pre-game at the 2000 Georgia-Florida game (Florida 30-Georgia 14), the trombone section raises their horns in the air as the drum line marches onto the field. (Courtesy Brett Bawcum.)

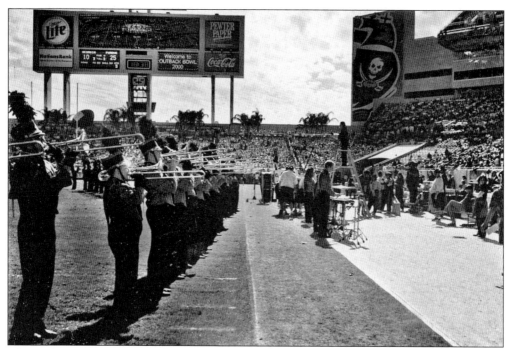

The Redcoats perform at halftime during the 2000 Outback Bowl in Tampa, Florida. Later in that game, Georgia overcame the largest point deficit in the history of bowl games by beating Purdue in overtime 28-25. (Courtesy Brett Bawcum.)

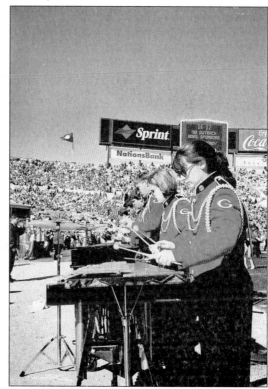

The front-line ensemble of the Redcoat drum line performs at halftime during the 1998 Outback Bowl. Selections from that show included Tchaikovsky's *1812 Overture*, complete with booming cannons. (Redcoat Band Archives.)

While bowl games give members of the band a chance to enjoy themselves after a long season, the band must still find time to practice in order to keep the shows in top form. Here the band practices at a Tampa-area high school for the 1998 Outback Bowl.

The Redcoat Band sousaphones warm up for rehearsals before the 2000 Georgia-Florida game. (Redcoat Band Archives.)

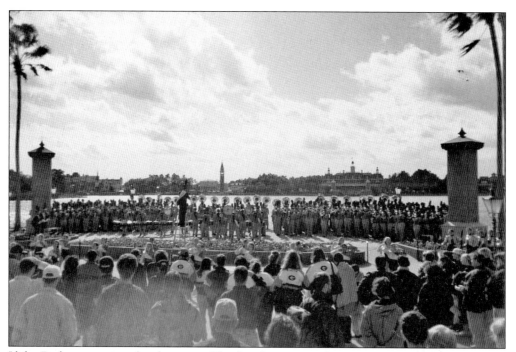

If the Redcoats are in a bowl game in Florida, chances are their itinerary gives them a chance to go to one of the theme parks at Disney World. Here the Redcoats perform at EPCOT Center during their trip to the 1998 Outback Bowl. (Author's collection.)

The Redcoats perform their Tate Center pep rally before a football game in 1999. (Redcoat Band Archives.)

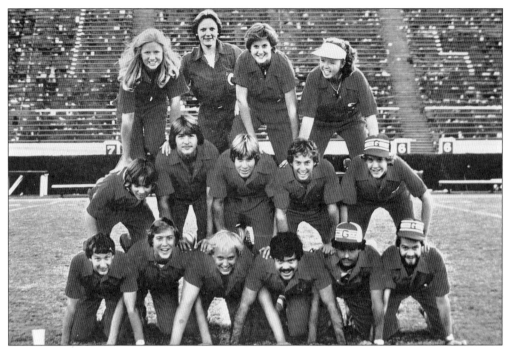

Members of the Redcoat Band properties crew pose for a picture inside Sanford Stadium in 1979. Formed in the late 1950s to help with the logistical aspects of the band, these people are among the hardest-working sections in the entire band, being the first to show up and the last to leave in most cases.

Members of the 2003 properties crew poses in Sanford Stadium during the Georgia-Alabama game (Georgia 37-'Bama 23). While the outfits may have changed, the workload certainly has not. Members of the 2003 crew include, from left to right, (front row) Matt Jensen, Molly Patton, Paralee Whitmire, Nicole Batten, Andrea Cannegeiter, Jessica Sellers, and props chief Trey Nihoul; (back row) Andrew Lavoie, Natalie Amoroso, Becki Ginsberg, Jad Johnson, Katie Charles, and Robin Richards. Not pictured are Patrick Hill, Alice Way, and Shawna Pile. (Redcoat Band Archives.)

Hairy Dog, one of the on-field mascots for UGA, conducts the Redcoats during the Georgia-Clemson game in 1995. (Author's collection.)

The trip associated with the annual Georgia-Florida game in Jacksonville is among the most anticipated trips of the year, as members get to spend a few days in St. Augustine, Florida, touring the sites and enjoying a break from classes. Here several Redcoats brave the cold waters of the Atlantic at St. Augustine Beach during the 1980s. (Redcoat Band Archives.)

Until the 1990s the band would sponsor a talent show and dinner for the band members, but the tradition was ended due to its costs. Here two members of the band perform a vaudeville-style show for their fellow band-mates. (Redcoat Band Archives.)

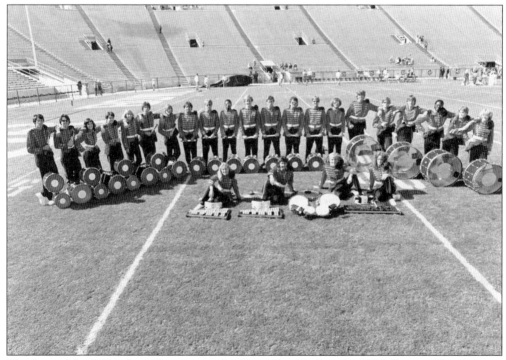

Members of the UGA drum line pose in the Gator Bowl before the 1982 Georgia-Florida game (Georgia 44-Florida 0). (Redcoat Band Archives.)

When the Redcoats were on television in the early days, more times than not they were on a regional broadcast. However, on rare occasions, the band could be televised nationwide. In 1973 a viewer mailed these photos to the band office showing them on TV . . . in Detroit! (Redcoat Band Archives.)

From left to right, Lamar Clark, Susan Rast, and Thomas Glanton, Redcoat drum majors from 1991–1992, pose in front of Uga's fire hydrant during a game in Sanford Stadium. (Redcoat Band Archives.)

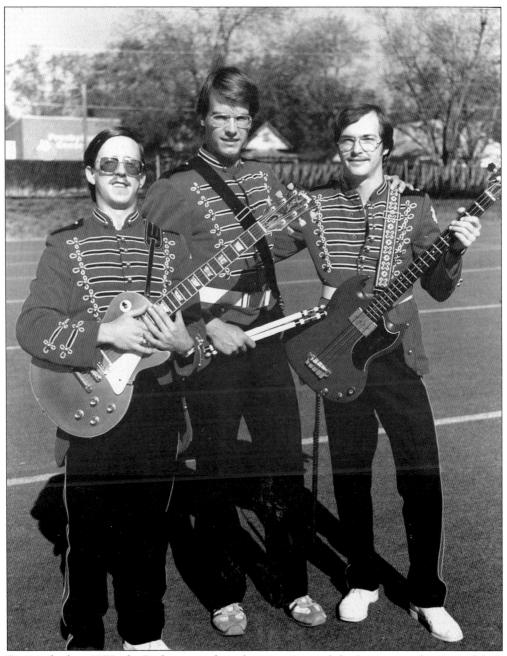

During the late 1970s the Redcoats used an electric guitar and rhythm section for some of their shows. Here, from left to right, members Alex Boskoff, Scott Campbell, and Phil Parsons pose for a photo on the Woodruff practice field. (Redcoat Band Archives.)

Georgia Reiche Brown was a feature twirler during the late 1960s. Feature twirlers for the Redcoat Band are heavily recruited from the ranks of the best baton twirlers in the nation. (Redcoat Band Archives.)

Known for his booming introduction "Keep your seats everyone . . . the Redcoats are coming," Tom Jackson, a former Redcoat member, has been the voice of the Redcoats since 1974. A former reporter for WXIA in Atlanta, he began announcing for the band at the 1974 Tangerine Bowl (Georgia 10-Miami [Ohio] 20). He is currently the associate vice president for public affairs at the university.

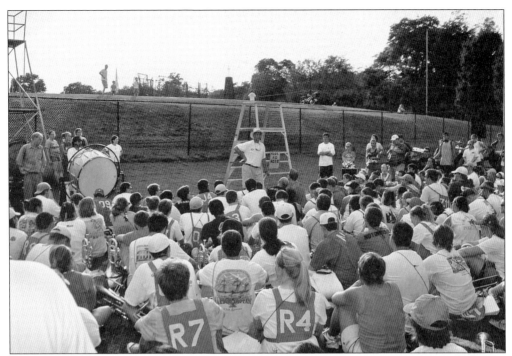

Prior to the start of the 2003 football season, head football coach Mark Richt talks to the members of the band, thanking them for their undying support over the years. (Redcoat Band Archives.)

On some occasions, the Derbies are called to play smaller events for the many Georgia alumni associations. Here the Derbies play at an event in the mid-1990s. (Redcoat Band Archives.)

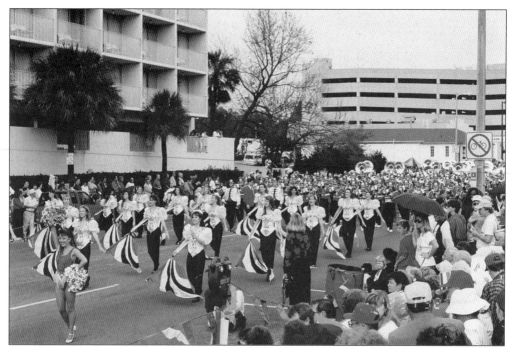

In 1993 the Redcoats traveled to Orlando to take part in the festivities for the Florida Citrus Bowl (now called the Capital One Bowl). Here the flag line is seen marching down Church Street past the main viewing stand. (Author's collection.)

As the Redcoats march in the Citrus Bowl Parade, feature twirler Candy Byrd (far left) performs her routine for the crowds. Now Candy Byrd Roland, she is the auxiliary coordinator for the Redcoat Band and is also a noted auxiliary choreographer and performer worldwide. (Author's collection.)

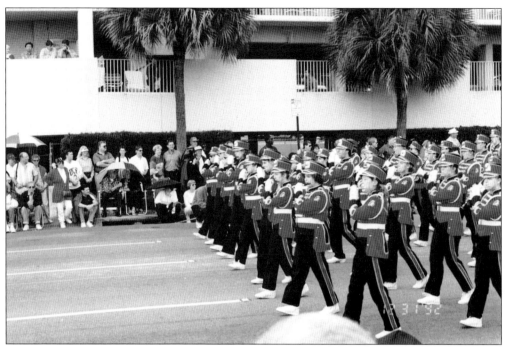

The piccolo section of the Redcoats marches by in the Citrus Bowl Parade. Georgia, under Coach Ray Goff, defeated Ohio State 21-14, capping the Bulldog's season at 10-2. (Redcoat Band Archives.)

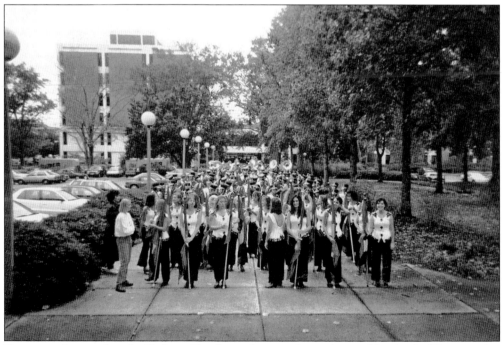

One commitment that the Redcoat Band must keep each year is marching in the Homecoming Parade. Here the band lines up in front of Boyd Hall before marching in the 1995 parade. (Author's collection.)

The Redcoat Band marches across Sanford Bridge during the 1995 Homecoming Parade. A few years later, the Homecoming Parade was moved to downtown Athens to give the citizens of Athens a chance to take part, as well as to draw more alumni. (Author's collection.)

By the 1990s the band room, as well as Stegeman Hall, could not accommodate the large number of students using the building. As a result, the Performing and Visual Arts Center (PVAC) was built in 1995 on the new East Campus, combining the band programs with the School of Music, which was previously housed in both the Fine Arts Building and Joe Brown Hall on the North Campus. (Redcoat Band Archives.)

Once the fall semester begins, the Redcoats' practice time reduces from 60 hours a week during band camp to 6 hours a week. They practice on Woodruff Field behind the Butts-Mehre Heritage Hall, the main offices for the UGA Athletic Association (the black building in background). (Author's collection.)

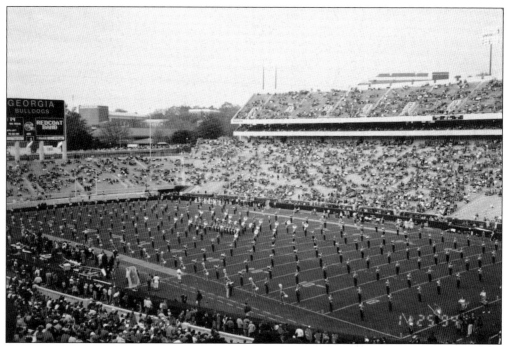

As Sanford Stadium slowly fills up, the Redcoats begin their pre-game show prior to the 1994 Georgia–Georgia Tech football game in Athens (Georgia 48-Tech 10). (Author's collection.)

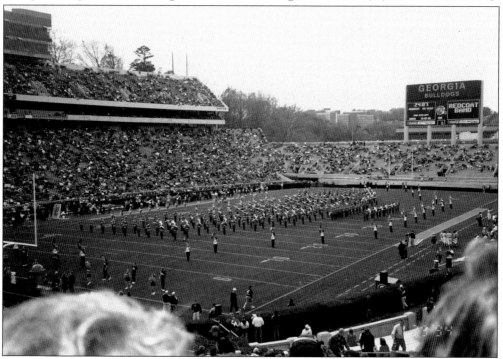

The Redcoats perform for the crowd prior to the 1994 Georgia–Georgia Tech game. This was the last home game the band played using the old uniforms, as the new uniforms were introduced in 1995 (see page 44). (Author's collection.)

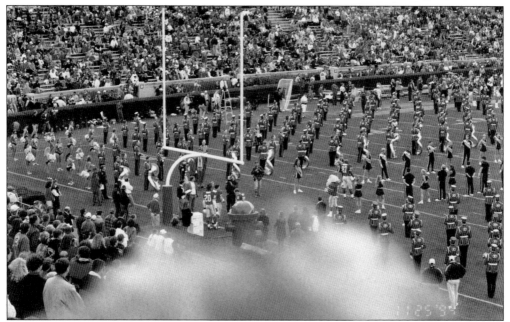

The Georgia–Georgia Tech game, when held in Athens, is made Senior Day. Here Georgia quarterback Eric Zeier (#10 behind the fire hydrant and below the goal post), one of the most prolific QBs in Georgia's history, is waiting to be introduced for the last time as a Bulldog and run through the tunnel formed by the band. (Author's collection.)

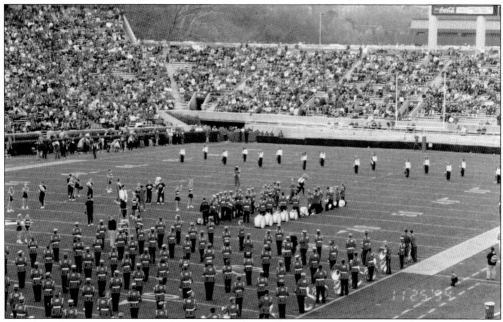

As the football seniors are being introduced, members of the drum line enjoy the rare occasion when they can take off their drums. As is the case at any Georgia–Georgia Tech game, anything can happen. Buzz, the Georgia Tech mascot, can be seen roaming the field inside the band, soliciting a chorus of boos from the fans (and perhaps a few thoughts of attack from the band members). (Author's collection.)

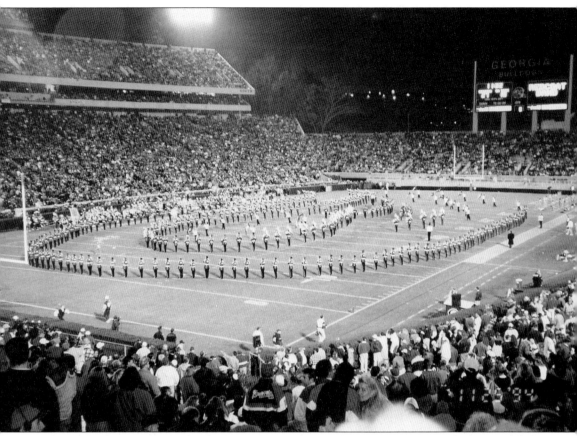

The Redcoats perform the last halftime show in Sanford Stadium for the 1994 season. While playing a show in Sanford Stadium can be an emotional experience, playing for the last time as a Redcoat can be an extremely emotional one as some members look back on their four years as a Redcoat. (Author's collection.)

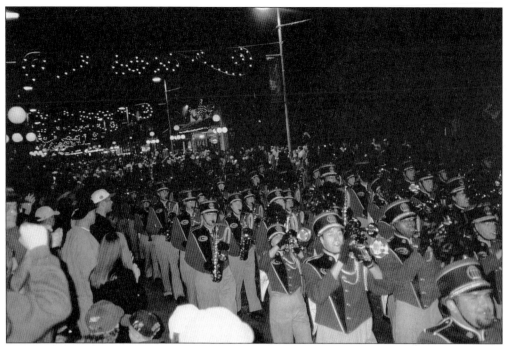

During the 1998 Outback Bowl, the Redcoats marched in Ybor City for the Outback Parade and pep rally. (Author's collection.)

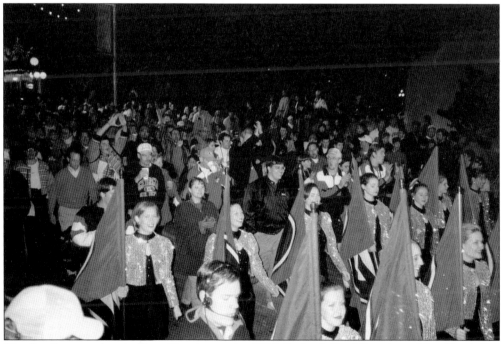

The flag line marches in Ybor City during the 1998 Outback Bowl Parade on New Year's Eve 1997. (Author's collection.)

Jereme Anne Thompson (at left) and Hope Carrell, feature twirlers during the 2003 season, pose in Sanford Stadium's northeast corner. (Redcoat Band Archives.)

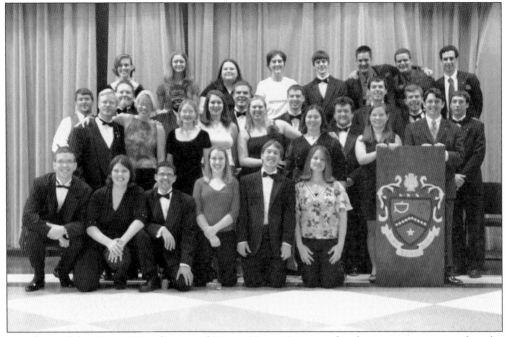

Members of the Kappa Mu chapter of Kappa Kappa Psi pose for their group portrait after the initiation of their "theta" (or eighth) class in April 2004, their fifth year of existence. (Courtesy Chapter President Phil Rubin.)

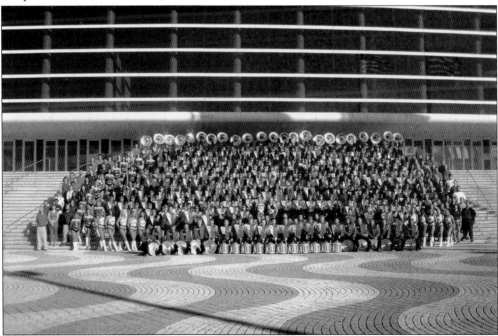

The 2003 Redcoat band poses for a group picture in front of the TD Waterhouse Center in Orlando, Florida, prior to marching in the Capital One Bowl Parade. Because of the enormous size of the band, such photos in recent years have been rare occurrences. (Courtesy Chris Cooper.)

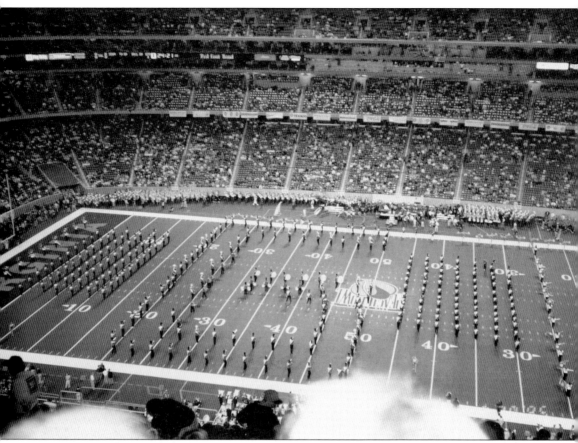

The Redcoats form the "block G" during their pre-game show at the 1995 Peach Bowl in Atlanta. (Author's collection.)

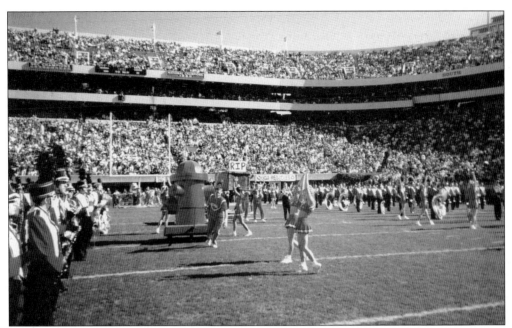

On October 28, 1995, the Georgia-Florida game was held in Athens for the first time since 1932 because of the construction of the new Alltel Stadium in Jacksonville. As the band pauses during their pre-game show, the cheerleaders get the 85,000-plus fans ready for the game. (Author's collection.)

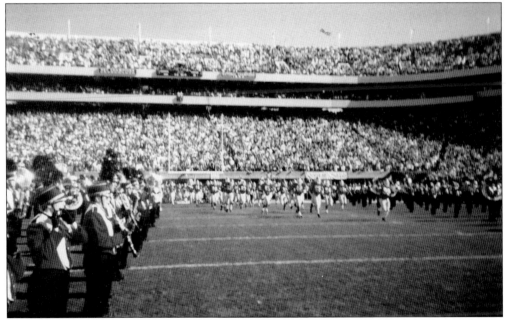

The football team runs onto the field for the 1995 Georgia-Florida game in Athens. Florida, lead by the "evil genius" Steve Spurrier, defeated Georgia 52-17, the first time any visiting team scored more than 50 points in Sanford Stadium. However, some Georgia fans did have reason to celebrate later that night, as the Atlanta Braves beat the Cleveland Indians to win the World Series. (Author's collection.)

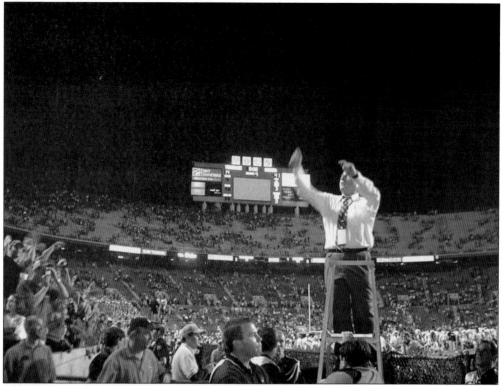

At the conclusion of the Georgia-Tennessee game in 2003, outgoing Athletic Director Vince Dooley was invited to conduct the Redcoats after the team's 41-14 victory over the Volunteers, making him the fifth non-Redcoat (after Coach Jim Donnan, Mike Bobo, Hines Ward, and Robert Edwards) to be given this honor. (Redcoat Band Archives.)

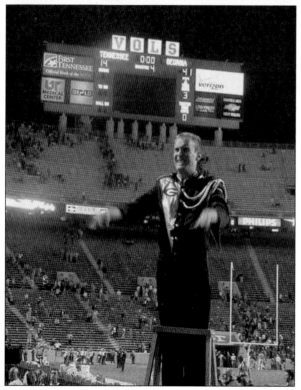

Matt Koperniak, a Redcoat drum major in 2003, conducts the band at the end of the Georgia-Tennessee game in Knoxville. (Redcoat Band Archives.)

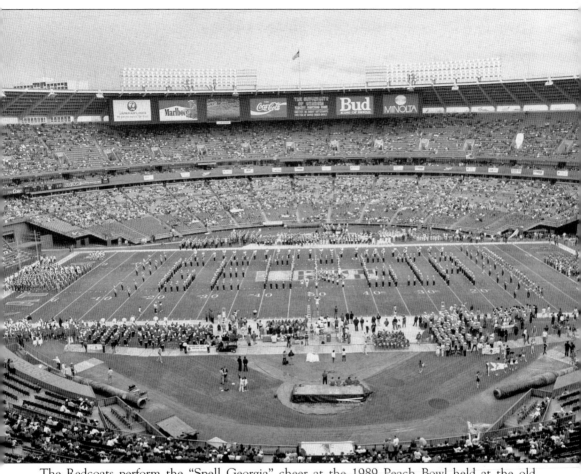

The Redcoats perform the "Spell Georgia" cheer at the 1989 Peach Bowl held at the old Atlanta–Fulton County Stadium (Georgia 18-Syracuse 19). (Redcoat Band Archives.)

The Redcoat Band performs in Sanford Stadium during the 1980s. Note the grassy hill in the northwest end zone. This would be covered with the construction of the west end zone seats after the 1991 season. (Redcoat Band Archives.)

Katy Fleming (center), a feature twirler from 1995 to 1999, poses with the sousaphone line in 1996. (UGA Sousaphones Website.)

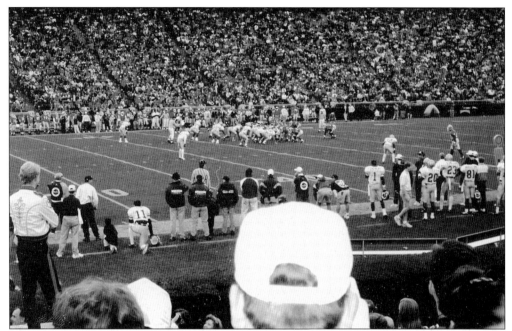

One of the perks of being in the Redcoats is being close to the action of a football game in some of the best seats in Sanford Stadium. Here the band watches the action during the 1994 Georgia–Georgia Tech game from seats near the 30-yard line. Two years later the band was moved to the northeast end zone corner (see page 70). (Courtesy Brett Bawcum.)

Sometimes the view can be just as good at certain away games. Here the band enjoys a good view at Clemson Memorial Stadium ("Death Valley") during the 1995 Georgia-Clemson game. Brett Bawcum, now the assistant director of bands at UGA, can be seen standing on the drum major's ladder. (Courtesy Brett Bawcum.)

When the Redcoats travel to an away game, at least one of the buses displays the Georgia state flag, as is the case here at the 2003 Clemson game (Georgia 30-Clemson 0). (Author's collection.)

At the end of every game, win or lose, Coach Richt walks over to the band section and thanks the band and the fans for their support, as is the case here after the 2003 Georgia-Clemson game. (Author's collection.)

One way the Redcoats raise funds is selling CDs. Here is the cover art for the current version of Game Day music. Other CDs range from music from their halftime shows to music performed by the many concert and symphonic bands at the university. (Redcoat Band Archives.)

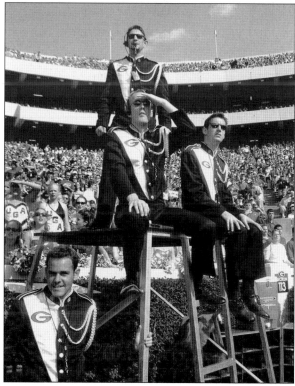

From top to bottom, 2003 Drum Majors Matt Haynor, Matt Koperniak (left), Ty Carnes (right), and Mitch Birnbaum watch the action on the field as they prepare to strike up the band during a time-out. (Redcoat Band Archives.)

Phi Mu Alpha members, from left to right, Jon Cotton, Chad Reynolds, Josh Luke, Jack Varner, Alan Hamm, Jon Tucker, Gus Godbee, Brandon Treadway, Stewart Marlow, Justin Long, Michael Bennett, Mitch Birnbaum, Matt Koperniak, Trey Nihoul, Will Marlow, Ty Carnes, Chris Cooper, Sammy Jones, and Jay Sconyers help out at the UGA Summer Music Camp in June 2004. The Epsilon Lambda Chapter of Phi Mu Alpha Sinfonia, the oldest and largest music fraternity in America, was chartered at UGA on January 14, 1950, and has since initiated 750 into its brotherhood. (Author's collection.)

Formed in 1940, the Iota Zeta Chapter of Sigma Alpha Iota, the female music fraternity at UGA, has never strayed from its mission to "encourage, nurture and support the art of music." SAI members, from left to right, Laura Hoadley, Megan Jones, and Valerie Worley continue that mission by assisting at the 2003 Summer Music Camp. (Author's collection.)

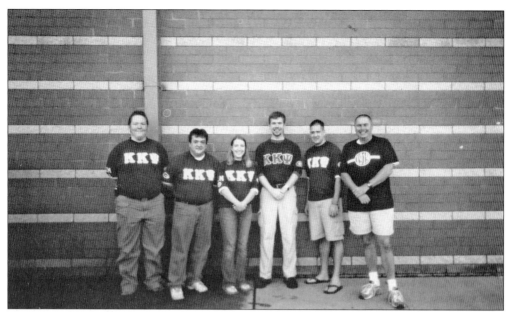

Kappa Kappa Psi members, from left to right, Chris Happel, Chris Cooper, Hayley Gallagher, chapter president Phil Rubin, Miguel Guisasola, and faculty sponsor Dr. David Romines take a break from working at the 2003 Summer Music Camp. Formed in 1999 at UGA, the Kappa Mu chapter of Kappa Kappa Psi is a coed fraternal organization that promotes the advancement of college and university bands.

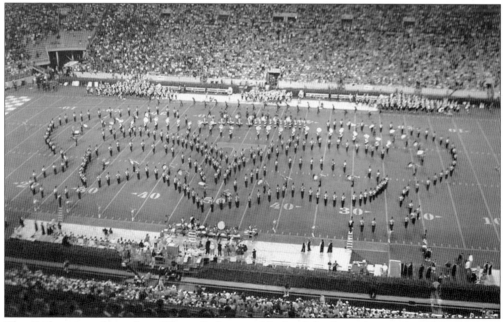

The Redcoats perform their "Queen" show in Neyland Stadium during the 2003 Georgia-Tennessee game. Minutes before, Georgia player Sean Jones ran back a fumble from Tennessee quarterback Casey Clausen (in front of cheering Redcoats on the sidelines), giving Georgia a 14-3 lead at halftime. Some people said the band never sounded better than that night. (Redcoat Band Archives.)

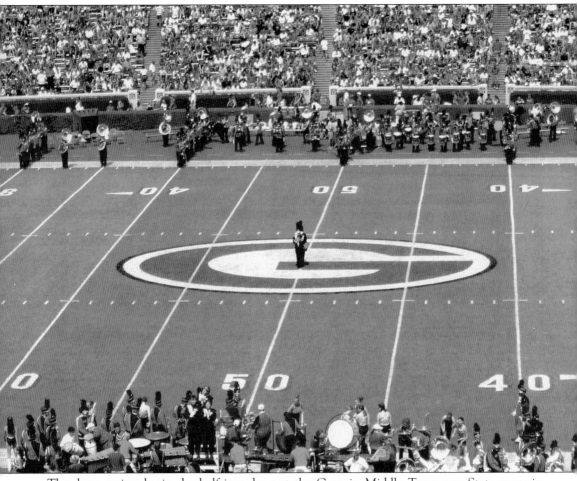

The drum majors begin the halftime show at the Georgia–Middle Tennessee State game in 2003 (Georgia 29-MTSU 10). (Redcoat Band Archives.)

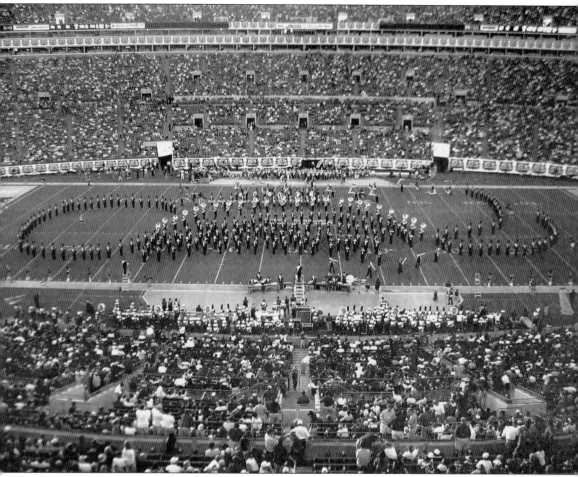

The band performs on the field of Alltel Stadium during the 2003 Georgia-Florida game (Georgia 13-Florida 16). (Redcoat Band Archives.)

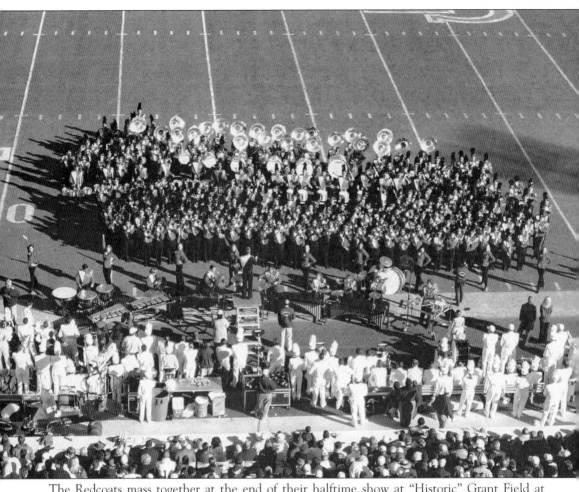

The Redcoats mass together at the end of their halftime show at "Historic" Grant Field at Bobby Dodd Stadium on the Georgia Tech campus.

The Redcoats form the Arch on the field during their pre-game show at the 2003 Georgia-Auburn game (Georgia 26-Auburn 7). (Redcoat Band Archives.)

The Redcoats perform the "Spell Georgia" cheer at the end of their show at the 2003 Georgia Tech game in Atlanta (Georgia 34-Tech 17).